the KODAK Workshop Series
Darkroom Expression

Yuten Konishi

*A posterization made from a color slide,
using the general technique described on
pages 62 and 63*

Darkroom Expression

Prepared by the editors of Eastman Kodak Company
with special outside writing contributions from

Hubert C. Birnbaum
Michael V. Bright
David A. Engdahl
Larry Sribnick
Jeff Wignall
Richard D. Za

the KODAK Workshop Series
Helping to expand your understanding of photography

Darkroom Expression

Prepared by the editors of Eastman Kodak Company with special outside writing contributions from

Hubert C. Birnbaum
Michael V. Bright
David A. Engdahl
Larry Sribnick
Jeff Wignall
Richard D. Zakia

Editor: Keith Boas

Book Design: Bill Buckett Associates, Inc.

Cover Photographs: Overall still life by Norman Kerr
 Others, clockwise from top left:
 Robert Clemens
 Keith Boas
 Robert Muller
 Keith Boas

Consumer/Professional & Finishing Markets
Eastman Kodak Company
Rochester, New York 14650

KODAK Publication KW-21
CAT 144 0866
Library of Congress Catalog Card Number 83-81294
ISBN 0-87985-300-X
4-84-CE New Publication
Printed in the United States of America

The Kodak materials described in this book are available from those photographic and graphic arts dealers normally supplying Kodak products. Other materials may be used, but equivalent results may not be obtained.

Since some materials for the processes described are substitutes and some techniques represent nonstandard uses of products, Eastman Kodak Company accepts no responsibility for the results derived by the use of this information.

KODAK, AUTOSCREEN, D-8, D-11, DK-50, D-76, DEKTOL, EKTACHROME, EKTACOLOR, EKTAFLEX, EKTAFLO, EKTALURE, EKTAMATIC, EKTONOL, HC-110, HRP, KODACHROME, KODAFIX, KODABROME, KODABROMIDE, KODALITH, KODAMATIC, MEDALIST, MICRODOL-X, PANALURE, PCT, PHOTO-FLO, PLUS-X, POLYCONTRAST, POLYFIBER, POLY-TONER, RESISTO, ROYALPRINT, SELECTOL, SELECTOL-SOFT, TECHNIDOL, VERICOLOR, VERSATOL and WRATTEN are trademarks.

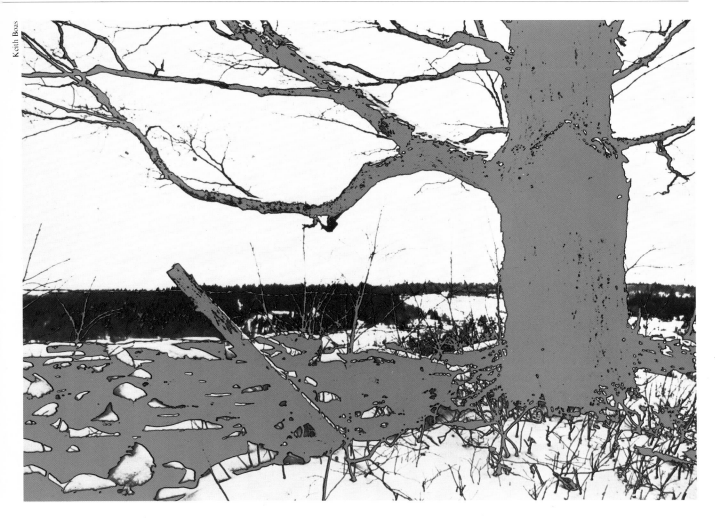

Keith Boas

The Sabattier Effect, pages 64 through 73

For Your Safety

Care is required in handling all chemicals. Photochemicals are no exception. For example, it is advisable to wear protective gloves to prevent skin contact with many photographic chemicals. Safe handling information for a particular Kodak chemical ordinarily can be obtained from the product label, the Material Safety Data Sheet (available from Publication Data Services, 343 State Street, Rochester, New York 14650), and Kodak publications such as *Safe Handling of Photographic Chemicals* (J-4) and *The Prevention of Contact Dermatitis in Photographic Work* (J-4S), available through your photo dealer.

For a list of Kodak publications and their prices, send for a free copy of *Photography Books from Kodak* (L-7). Write Dept. 412 L, Eastman Kodak Company, Rochester, NY 14650.

Measurements shown in this book are U.S. customary units followed by the metric equivalent in parentheses except for common, frequently mentioned film and paper formats. To avoid redundancy and conserve space, metric equivalents on the following formats will appear only here:

4x5 inches (10x12.7 cm)
5x7 inches (12.7x17.8 cm)
8x10 inches (20.3x25.4 cm)
11x14 inches (28x36.6 cm)

Contents

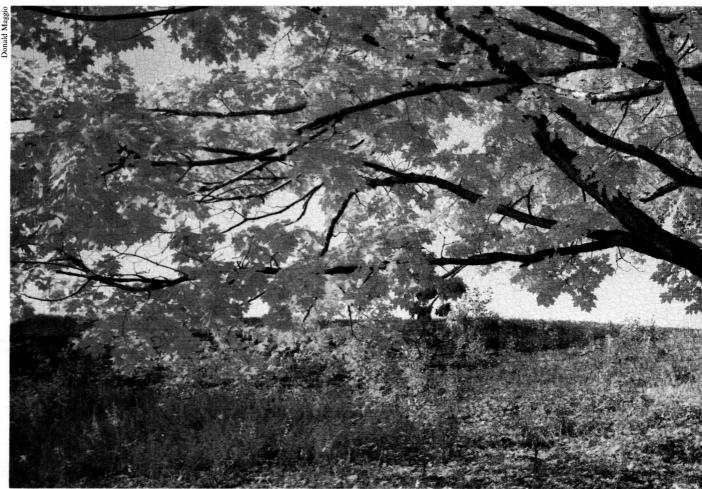

Donald Maggio

Adding Texture--pages 74 through 79

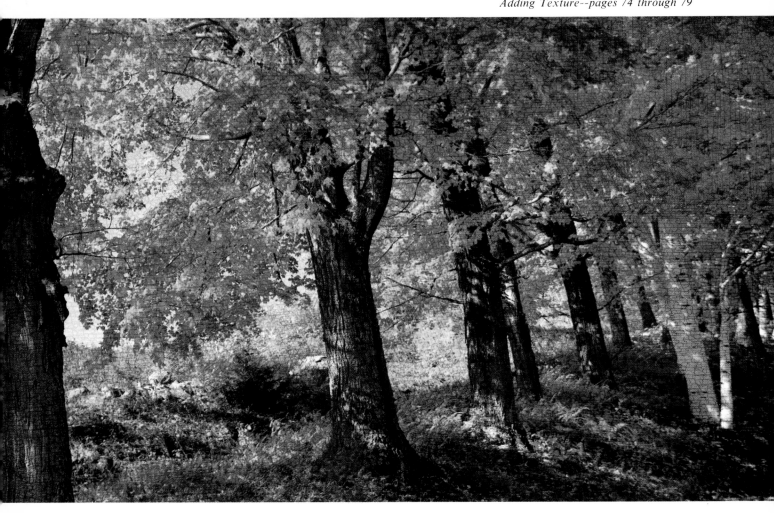

John Lew

Introduction

The aura of the darkroom, with its amber glow and its bottles, beakers, timers and trays, presents a magnetic attraction to the scientist in each of us. But aside from its laboratorial enticement, it also is the creative playground of the imaginative photographer — the setting where latent, artistic ideas become final realities on photographic film or paper.

Darkroom Expression assumes that you have entered this environment of enlargers, easels, safelights and sinks a time or two before and have an understanding of the processes and procedures required to make good-quality prints. The book picks up the story at this point to help you make even better prints from your existing negatives and slides and shows you how to derive new images from them.

Many of the techniques covered in the book, such as diffusion, the Sabattier Effect, hand-coloring, and adding texture, are regaining popularity as art forms that allow serious photographers avenues for expressing themselves visually. Other techniques are new — presenting fresh challenges while employing the latest in color-emulsion and processing technology.

State-of-the-art negative and reversal materials, coupled with established methods in the arena of high-contrast imagery, make the graphic techniques of posterization, solarization and tone-line easier and more enjoyable to perform than ever before.

In short, the pages that follow contain a bountiful bag of creative tricks and ideas that can launch you into new directions — possibly as both a fine-art exhibitor and a commercial illustrator. Study the chapters and practice the techniques they present. You'll be proud of the exciting, new images you can conjure and the degree of professionalism you will achieve in your photography.

Making High-Contrast Derivations, pages 44 through 53

Finding your way in the darkroom

One of the undisputed masters of photography, Henri Cartier-Bresson once observed that you really don't become visually aware with a camera until you are so familiar with its mechanics and capabilities that it becomes an extension of your eye. Only then will you start to see and record successful pictures routinely.

A parallel situation looms in the darkroom. Until you are confident and comfortable with the use of the equipment and software that help produce tangible photographs, you may be a little unsteady in your ability to visualize your final image.

Presented in this section are tables to help clarify confusion about many of the substances, conversions and compatibilities that are used in the darkroom. As questions arise, you can use these data for quick reference to speed you on your way toward your major objective of making fine photographs.

CODE NOTCHES

Most Kodak sheet films are code-notched for identification. The position of the notch—always in the same location—tells you which is the emulsion side when working in the dark. When the notch is in the right-hand side of the top edge of the film sheet, the emulsion side is facing you.

CODE NOTCHES FOR *KODAK* SHEET FILMS MENTIONED IN THIS BOOK

Commercial 6127

KODALITH Ortho 2556,
Type 3 (no notch)

KODALITH Pan 2568

EKTAFLEX PCT Negative

EKTAFLEX PCT Reversal

VERICOLOR Print 4111

KODAK EKTAFLEX PCT PRODUCTS FOR COLOR PRINTING

For color prints from negatives and slides in minutes, using a motorized processor such as the KODAK EKTAFLEX PCT Processor, Model 8, Model 12, or equivalent

	Characteristics	*Process*
EKTAFLEX PCT Paper	Resin-coated with special emulsion for making high-quality color prints by image transfer with either EKTAFLEX PCT Negative Film or EKTAFLEX PCT Reversal Film	EKTAFLEX PCT Activator
EKTAFLEX PCT Negative Film	Multilayer color film that produces dyes for making color prints from negatives by color-image transfer onto EKTAFLEX PCT Paper	
EKTAFLEX PCT Reversal Film	Multilayer color film that produces dyes for making color prints from transparencies by color-image transfer onto EKTAFLEX PCT Paper	

KODAK ENLARGING PAPERS FOR BLACK-AND-WHITE PRINTING

Selective-Contrast Papers

POLYFIBER™	Selective-contrast enlarging paper with brightened fiber base
EKTAMATIC SC	For stabilization processing in processors such as the KODAK EKTAMATIC Processor, Model 214-K. Also can be tray-processed
POLYCONTRAST Rapid II RC	Resin-coated with warm-black image tone. Brightener for crisp, clean whites. Can be processed by tray or machine with KODAK ROYALPRINT Processor

Graded Papers

EKTALURE	Fiber base with brown-black warm image tone. For portrait and exhibition prints
KODABROME II RC	Resin-coated with warm-black image tone. Brightenerer for crisp, clean whites. Can be processed by tray or machine with ROYALPRINT Processor.
KODABROMIDE	Fiber base with neutral black image tone for general-purpose work. High speed for shorter exposures
MEDALIST	Fiber base with warm-black image tone for general-purpose work. Wide exposure and development latitude
Mural	Fiber base with warm-black image tone. Extra strength and abrasion resistance to withstand folding and handling

Panchromatic Papers for B/W Prints from Color Negatives

PANALURE II RC	Resin-coated with warm-black image tone. Useful in commercial, portrait, and school photography
PANALURE	Fiber base with warm-black image tone
PANALURE Portrait	Fiber base with brown-black image tone

TEMPERATURE CONVERSION CHART

Degrees Fahrenheit to Degrees Celsius

°F	°C	°F	°C	°F	°C
45	7.0	74	23.5	102	39.0
46	8.0	75	24.0	103	39.5
47	8.5	76	24.5	104	40.0
48	9.0	77	25.0	105	40.5
49	9.5	78	25.5	106	41.0
50	10.0	79	26.0	107	41.5
51	10.5	80	26.5	108	42.0
52	11.0	81	27.0	109	42.5
53	11.5	82	28.0	110	43.5
54	12.0	83	28.5	111	44.0
55	13.0	84	29.0	112	44.5
56	13.5	85	29.5	113	45.0
57	14.0	86	30.0	114	45.5
58	14.5	87	30.5	115	46.0
59	15.0	88	31.0	116	46.5
60	15.5	89	31.5	117	47.0
61	16.0	90	32.0	118	47.5
62	16.5	91	32.5	119	48.5
63	17.0	92	33.5	120	49.0
64	18.0	93	34.0	121	49.5
65	18.5	94	34.5	122	50.0
66	19.0	95	35.0	123	50.5
67	19.5	96	35.5	124	51.0
68	20.0	97	36.0	125	51.5
69	20.5	98	36.5	126	52.0
70	21.0	99	37.0	127	52.5
71	21.5	100	37.5	128	53.5
72	22.0	101	38.5	129	54.0
73	23.0			130	54.5

The degrees Celsius have been rounded off to the nearest 1/2 degree.

KODAK BLACK-AND-WHITE DEVELOPERS

KODAK Developer	*Contrast*	*Special Properties*	*Usually Employed For*
D-8	Very High	High capacity; rapid development	Continuous-tone and process films
D-11	High	General purpose for high contrast	Continuous-tone and process films
D-19	High	High capacity; rapid development	Instrumentation films; scientific plates
DK-50	Medium	General purpose	Sheet and 70 mm films
D-76	Medium	General purpose; full emulsion speed; low fog	Roll, sheet, 35 mm films
DEKTOL	Medium	High capacity; rapid development	Contact and Enlarging papers
EKTAFLO, Type 1	Medium	High capacity; rapid development	Cold- and neutral-tone Contact and enlarging papers
EKTAFLO, Type 2	Medium	High capacity; useful for papers to be toned	Warm-tone contact and enlarging papers
EKTONOL	Medium	Especially for papers to be toned	Warm-tone contact and enlarging papers
HC-110	Medium	General purpose and very versatile	Roll, sheet, 35 mm films; graphic-arts films
KODALITH	Very High	Rapid development	Process, reproduction and graphic-arts films, plates and papers
KODALITH Super	Very High	Rapid development	Process, reproduction and graphic-arts films, plates and papers
HRP	High	High capacity; high image quality	High resolution plates
MICRODOL-X	Medium	Fine-grain	Roll and 35mm films
SELECTOL	Medium	Useful for papers to be toned	Warm-tone papers
SELECTOL-SOFT	Medium	Similar to SELECTOL but lower in contrast	Warm-tone papers
TECHNIDOL LC	Low	Fine-grain. Lowers contrast of KODAK Technical Pan Film 2415 to produce medium-contrast negatives	KODAK Technical Pan Film 2415
VERSATOL	Medium	General purpose	Roll films, contact and enlarging papers

STOP BATHS FOR BLACK-AND-WHITE PROCESSING

KODAK EKTAFLO Stop Bath	Concentrated liquid with built-in color indicator to signal exhaustion.
KODAK Indicator Stop Bath	
KODAK Universal Stop Bath	Powder supplied in packet to make 8 oz of working solution. Built-in color indicator to signal exhaustion.

FIXING BATHS FOR BLACK-AND-WHITE PROCESSING

KODAFIX Solution	Single-solution concentrated hardening fixers for general use with film or paper.
KODAK EKTAFLO Fixer	
KODAK Fixer	Hardening fixer for general use with film or paper.
KODAK Photo-Fix	Economical hardening fixer, especially for prints.
KODAK Rapid Fixer	Rapid-acting hardening fixer for general use. Consists of two liquid concentrates: fixer concentrate and hardener concentrate.

Your controls

by Hubert C. Birnbaum

When you're about to venture from the main road of conventional image-making, it helps to recall the ancient Chinese adage that even the longest journey begins with a single step. In fact, the most elaborate darkroom techniques, as you will see in following pages, are for the most part composed of individual steps involving conventional and quite simple standard procedures. When these steps, or basic building blocks, are assembled in innovative ways, striking pictorial effects can result.

A soft, romantic quality can be added to a picture by diffusing its projected image during enlarging. See pages 22 and 23.

Robert Clemens

The basic controls presented in this chapter include several, such as dodging and burning in, with which you are probably already familiar, and others, such as flashing, intensifying and reducing, that you may not have practiced yet. Consider them prime components in your tool kit of darkroom skills. Each can be used not only as a corrective device to achieve high-quality conventional rendition, but also to create unusual visual effects.

ENLARGER ALIGNMENT

The center of attention for all darkroom activities involving an enlarger should be an enlarger that is properly aligned. That means the negative stage, lens board and baseboard must be parallel. If all three are not parallel, you may not be able to make prints consistently that are uniformly sharp from corner to corner or across the image.

Many enlarger designs allow checking alignment easily with a small carpenter's level or bubble level. First see that the baseboard is level front-to-back and side-to-side. If not, place thin shims below the appropriate support studs to level it.

Next check the level again with the easel in place to make sure that it is level and that its weight has not altered alignment of the baseboard.

Then check the negative stage by placing the level on one fore-and-aft edge and again on the front or rear edge. If there isn't enough clearance to insert the level, place on the negative stage a thin, flat, rigid metal or plastic sheet that is large enough to extend beyond the front and one side of the stage to accept the level. Close the head gently on the plate to hold it in place.

Check the lens board for parallelism by gently pressing the flat plate of the level against the front ring of the lens as shown in the photo. Next perch the level first on a front and then on a side edge.

Check the negative stage with the enlarger head at several different heights above the baseboard, with friction locks, if any, tightened normally. Check the lens board at various points in its vertical travel.

If you notice any significant misalignment, consult the owner's manual supplied with the enlarger for instructions as to how to realign the enlarger, or contact the distributor's service department for information. Some enlargers can be adjusted easily simply by applying common sense. Others may require special tools or procedures best done by authorized service technicians.

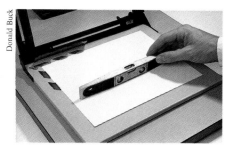
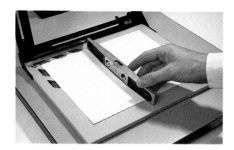
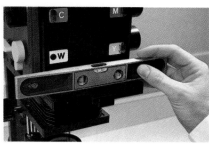
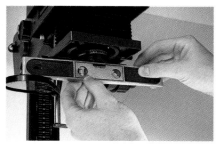

*The first step in verifying enlarger alignment is to level the baseboard, **above left and right.** If necessary, shim it until it is level front to back and side to side. Next check negative-stage alignment, **left.** If there isn't enough clearance to place the level directly on the negative stage, insert a flat, rigid plate on the stage as though it were a* *too-large negative carrier. The plate should be large enough to provide overhangs on which to rest the level. Finally, check lens alignment, **right,** by holding the level against the front ring of the enlarging lens. Check alignment of negative stage and lens both front to back and side to side.*

Laura Bethel

ENLARGER VIBRATION

An enlarger is like a camera in that any movement or vibration during exposure will degrade the image by causing unsharpness. For best print sharpness, you want the enlarger to be very steady during exposure. Wait several seconds after adjusting the enlarger before you start the exposure to allow time for any vibrations to stop. Don't touch the enlarger or the platform supporting it during the exposure. And unless you have a concrete floor, don't move about the darkroom during exposure.

If your darkroom is subject to vibrations from nearby machinery or heavy traffic, you can isolate the enlarger to some extent by supporting the baseboard on elastic cushioning material. Although the enlarger might still move in response to rumbles and thuds, it should move as a unit, and sharpness will suffer less. If possible, print during lulls or times of reduced activity.

*These two enlargements were made identically except that the print **above** was exposed with the enlarger vibrating. The steadier the enlarger, the sharper the print.*

Keith Boas

*Tilting the camera to include the roof and chimney produced the perspective effect called **convergence**, in which parallel subject features record as convergent. In reprinting the picture, the convergence was corrected and parallelism restored.*

CONVERGENCE CONTROLS

Convergence is the perspective effect in which lines that are parallel in reality are depicted as converging, or tending to meet, in the picture. It is associated with photos of tall buildings made with the camera tilted to include their tops. The buildings appear to lean back and taper. You can correct for convergence when printing by one or more procedures, depending on the design of your enlarger.

Correcting Convergence

The simplest way to correct convergence is to raise one end of the easel (Figure 1) until parallelism is restored; then prop the easel at that height. Refocus the image for best sharpness at a point about 1/3 below the raised end of the easel and stop the enlarging lens down until the image is sharp overall. If the easel is tilted appreciably, you may not be able to attain overall sharpness by this method. Depending on the amount of tilt required, you also may have to dodge the image toward the upper end of the easel to even out exposure of the print.

If you can tilt the head, negative stage and/or lens stage of your enlarger, you then can correct convergence by: tilting the head and lens stage relative to a level easel (Figure 2); tilting the head and easel while maintaining a level lens stage (Figure 3); and tilting easel and lens stage relative to a level negative stage (Figure 4).

These methods offer the advantage that when the extended planes of easel, lens stage and negative stage meet at a common point in space, the image will be uniformly sharp even with the lens wide open. This is an application of the Scheimpflug principle, used by view-camera photographers to maximize depth of field.

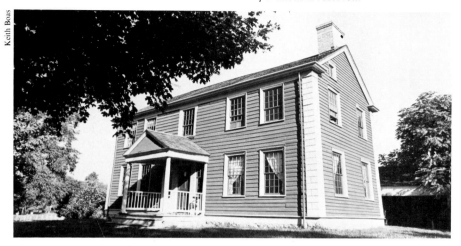

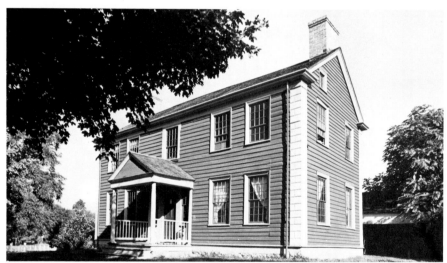

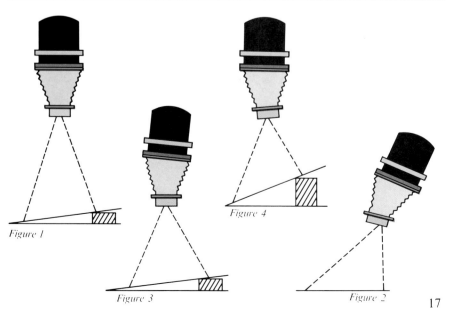

Figure 1

Figure 4

Figure 3

Figure 2

17

Deliberate Distortion for Impact

The techniques described on the previous page for restoring a more natural look can also be employed to exaggerate or distort subject rendition for dramatic impact, novelty or humor. You can make subjects look disproportionately large or small and short or long by tilting the easel and/or various enlarger components to produce the effect you want. You needn't remember any rules, as you can see from the projected image whether or not you care for a particular effect.

Exposure Tests

Whether correcting or inducing convergence, expose one or more test strips running the full width or length of the easel, depending on the direction of the tilt, before exposing a full sheet of enlarging paper. The test strip(s) will show how much dodging is required, if any, to achieve uniform print density.

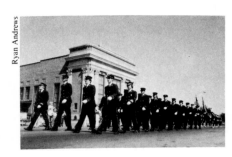

The original picture, taken at ground level on KODAK PLUS-X Pan Film with a 24 mm lens, shows only slight keystone distortion in the straight print.

To vertically "stretch" the marching firemen for a special effect, the enlarger easel was tilted considerably.

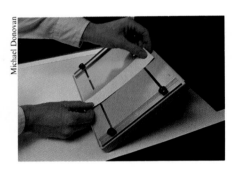

*Make a full-length test strip when tilting the easel. It will show how much dodging must be done, if any, to attain uniform exposure from one end of the print to the other. This illustration shows the approximate amount of easel tilt needed to make the corrected print on the previous page. For the deliberate distortion in the photograph **above,** an even greater amount of tilting was required.*

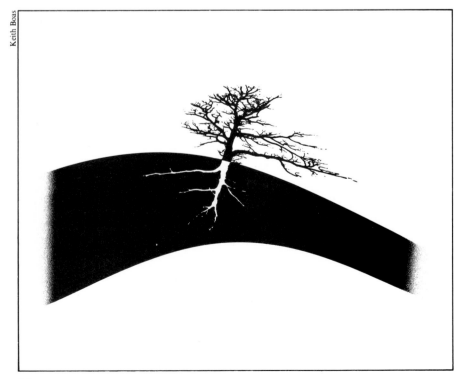

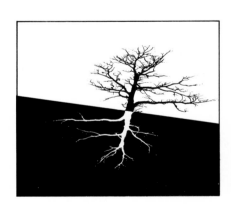

*The principle of convergence-control elongation can be used imaginatively to enhance a picture. To create the deliberately distorted photo, **left,** the photographic paper was bowed upward substantially so that its center was much closer to the enlarger lens than its left and right edge. **Above** is the straight (undistorted) print made from the same high-contrast negative.*

DODGING

Dodging means reducing print exposure locally by shielding a portion of the printing paper from image-forming light during part of the overall exposure. You can use your hands or dodging tools made of black cardboard or other opaque materials to cast the shadows that selectively lighten the image. Whatever you use, keep the dodger moving to prevent creating unwanted and obvious demarcation lines between dodged and fully exposed areas. Raise and lower the dodger and jiggle it continuously in an erratic circular path centered above the area to be lightened.

Hands Versus Dodging Tools

You can dodge large, free-form areas easily with your hands. For dodging small, isolated areas, such as a face in a crowd, you'll find it easier to use a dodging tool. You can buy them ready-made or make your own by gluing or taping bits of black cardboard cut in a variety of shapes to lengths of black coat-hanger wire. If you have to dodge a relatively large area with an intricate border, project its image about a quarter- or half-size onto a sheet of cardboard, trace the outline and cut the cardboard to use as a made-to-order dodger.

Dodging with Filters

In printing color negatives, you can use gelatin color compensating (CC) filters to alter the color of an area while lightening it. For example, if the sky in a landscape looks too dark and slightly yellow, you might dodge it through a CC10 or CC20 yellow filter to lighten it and make it look more blue simultaneously, without affecting color balance in the remainder of the print.

In reversal color printing, if the sky looks too light and yellow, you can dodge through a blue CC filter to make it darker and more blue.

Ryan Andrews

In black-and-white printing with selective-contrast papers, such as KODAK POLYFIBER Papers and KODAK POLYCONTRAST RC Papers, dodging through a KODAK POLYCONTRAST Gelatin Filter will both lighten the affected area and alter its contrast. The effect is easiest to predict when the basic print exposure is made with no filter for normal contrast. Then the dodging filter will have the contrast effect usually associated with it. When the dodging filter is used in conjunction with another contrast filter, make test strips to determine the cumulative effect.

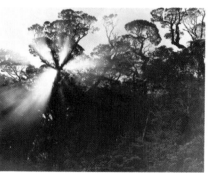

*In color printing, you can dodge through filters to change color rendition in limited areas without affecting overall balance. In the straight print, **bottom,** made from a color negative, the sunburst and surrounding sky look uninspiring. Dodging this area through a CC40 blue filter yielded the warmer color balance, **top.** To compensate for filter absorption, this area then was burned in for a few seconds with the same filter.*

Michael Donovan

You can make or buy dodging aids in a variety of shapes and sizes to cast controlled shadows.

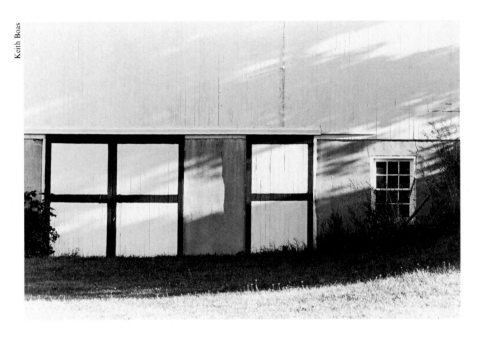

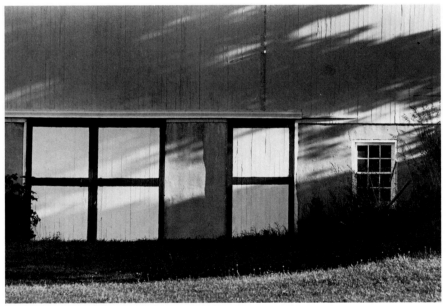

*In the straight print, **top**, the massive shadow falling on the white siding of the barn has an interesting shape but is washed out. The strip of grass in the foreground, being in the sun, also is too light. In the final print, **bottom**, each of these areas was given additional exposure to produce darker, more appealing tones.*

BURNING IN

Also known as printing in, burning in is basically the opposite of dodging. It consists of giving additional exposure to one or more limited areas of a print to darken them. As with dodging, you can use your hands or artificial aids to control the size and shape of the area that receives additional exposure. And again, as in dodging, your hands or the device you're using must stay in motion to avoid forming too obvious a boundary between the burned-in area and the rest of the image in the print.

Controlling Light

Much routine burning in can be done simply by forming an aperture of appropriate size and shape with your hands and letting additional image-forming light flow through it as long as necessary to achieve the amount of darkening desired. If you cannot conveniently shape the light with your hands, cut a suitable aperture in the middle of a sheet of black cardboard. With black-and-white materials, a sheet of stiff, dark red, transparent plastic with a small hole in the center is handy for burning in small areas. The red material acts as a safelight filter through which you can see the protected portion of the image around the area you're burning in.

To burn in an intricately shaped area, lower the enlarger so the projected image is about half size, then trace it onto a sheet of opaque paper or cardboard. Next carefully cut out the area to be burned. When making the final, full-size print, use the cut material with the hole as your burning-in tool—moving it slightly during exposure while holding it about halfway between lens and paper.

Burning in with Filters

With selective-contrast black-and-white papers, you can change filters for the burn part of the exposure. If you're trying to darken a very bright highlight, you can switch to a soft-contrast filter for the burn exposure to shorten the time appreciably.

In color printing, burning in through a CC or deeper hued filter lets you alter the color in selected areas without affecting overall color balance.

Estimating Exposure

The easiest way to determine a starting exposure for dodging or burning in is to ask yourself how much lighter or darker you want the area to look, and answer the question as a percentage. If you want an area to look about 50 percent lighter, dodge it during half the overall exposure. If you want an area to look 25 percent darker, expose it about 25 percent longer than the basic exposure. Such estimates will get you close to what you want, but there is no substitute for careful test printing. The actual relationship between the density change you desire and the exposure adjustment required is dependent upon the contrast of the photographic paper.

Generally, burning in blocked (very dense) highlights will require more exposure than the initial estimate indicates, sometimes much more. With dodging estimates, be more conservative. Excessive dodging of dark areas can create nasty looking pools of swampy gray in black-and-white prints and smoky, off-color murk in color prints.

In corrective applications, skillful dodging and burning in pass unnoticed, blending subtly into the fabric of the image. When used to create personal interpretations, they can be as muted or blatant as your inner vision demands.

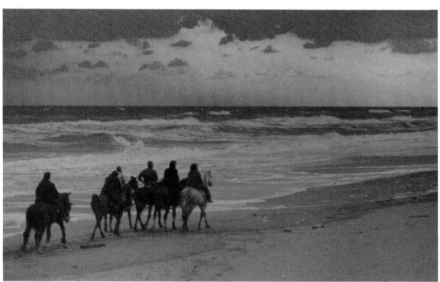

QUANTITY PRINTS

If you foresee a need for a relatively large number of prints of a picture that requires intricate dodging or burning in—or both—you can save considerable time and energy by making just one top-quality enlargement embodying all the corrections or special effects you want. Then make the best copy negative you can from the print, and print your desired quantity from the copy negative.

In this comparison, made from a color negative, the mood was enhanced, **bottom,** *by burning in the sky with a No. 38A deep blue gelatin filter. The sky area, in addition to the overall base exposure of 15 seconds, received an additional 90-second exposure through the filter.*

DIFFUSION

Most darkroom procedures are oriented to producing the sharpest possible results. However, there are times when a touch of softness can lend an airy, romantic feeling to a high-key picture; a note of mystery to a low-key scene; or a pleasant, flattering look to close-ups of people. Softening the image during printing is done through diffusion, which consists of interfering with the image-forming light enough to spread shadows into highlight areas. Details are rendered less precisely and contrast is reduced.

Diffusion Methods and Materials

The easiest but least controllable way to soften the image is to tap the enlarger to induce vibration during the print exposure. For more predictable effects, you can place a variety of ready-made or improvised diffusers between the enlarging lens and the easel. Diffusion discs of glass or plastic are available in a variety of strengths through photo dealers. You also can make diffusers of sheer netting, fine wire mesh, window screening, crumpled cellophane, plastic wrap or optical glass flats completely or partially smeared with clear petroleum jelly or daubed with colorless nail polish.

When you hold an improvised diffuser beneath the lens, keep it moving to prevent a distracting pattern from being recorded in the image. Diffusers for black-and-white enlarging can be any color, although black will cause less flare than lighter shades. For color printing, use white or black diffusers unless you want to induce color casts. When printing from a color negative, remember that a colored diffuser will impart a complementary (opposite) cast to the print. (For more information on complementary colors, see page 42.)

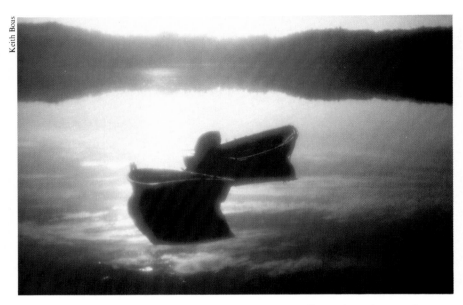

Keith Boas

Softening the image through diffusion can create romantic, ominous, or flattering effects, depending on the subject.

Amount of Diffusion

You can control the amount of diffusion in a print through your choice of diffuser, how long you allow it to remain in the light path relative to the total exposure time, and sometimes by altering the aperture of the enlarging lens. The more the diffuser disrupts the projected image, the softer the resulting picture will be. The longer the diffuser affects the image, the softer the result will be. And with some diffusion devices mounted immediately beneath the enlarging lens, the larger the lens aperture, the softer the image will be.

As a starting point, try diffusing the image for about one-third of the total exposure time. The undiffused portion of the exposure will provide a sharp base image, and the diffused part will provide slight softening of detail. Many photographers find this ratio useful for smoothing complexions in portraiture.

Overall Diffusion

The most prevalent form of diffusion involves softening the entire image simultaneously. If you intend diffusing for half the exposure time or longer, anticipate an overall reduction in contrast equivalent to about one full paper grade. You may wish to compensate for it by selecting a higher-contrast paper or control filter. A test strip or print will show how much contrast adjustment, if any, is required.

Aside from softening image detail, overall diffusion also softens whatever graininess may be apparent in an enlargement. If you ever have to make a big enlargement from an excessively grainy negative, diffuse during about one-tenth to one-quarter the total time to take the edge off the graininess without degrading image detail to the point of obvious unsharpness. Tread lightly here, because there is a fine line separating softened graininess from a softened picture.

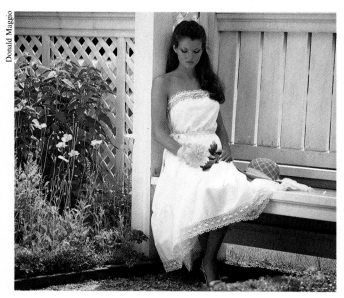

Donald Maggio

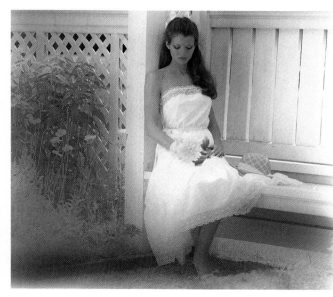

Straight print

You can diffuse part of the image, leaving the rest sharp, by applying petroleum jelly to a glass sheet. Then hold the glass under the enlarger lens during exposure to disrupt that portion of the picture you wish to diffuse.

This print was exposed through a 75 mm square Spiratone No. 2 (strong-diffusion) filter for the full exposure time. Ready-made diffusers are available through photo dealers in a variety of strengths, shapes and sizes.

Selective Diffusion

You can diffuse part of a picture without affecting the sharpness of other areas. You might do this to suppress visual clutter in a busy background or to flatter a face without modifying other elements in the scene.

If you use large enough film sizes and your enlarger has a glass negative carrier, apply a thin layer of clear petroleum jelly or colorless nail polish to the top glass surface directly above the portion of the negative you wish to diffuse. Blend or feather the edges of the diffusion medium to prevent printing a sharp boundary line. The more diffusion medium you apply, the softer the image.

Another approach to selective diffusion is to make diffusion aids similar to the tools you use for dodging and burning in. Form a length of black coat-hanger wire into a small loop at one end, glue a swatch of diffusion material over the loop, and trim it neatly. Then cut a hole in a sheet of black cardboard and fasten diffusion material over the hole. Use either implement to diffuse small areas, depending on whether it's better to hold back slightly or burn in.

Still another handy way to diffuse selectively is with a clean glass sheet to which you have applied clear petroleum jelly or colorless nail polish in a suitable pattern. Hold the glass beneath the lens so the diffusion medium affects only the area of the image you wish softened. Hold it steady if you want a hard-edged border between sharp and unsharp areas, or move it slightly for a more gradual transition.

When applying selective diffusion to pictures exhibiting pronounced graininess, go easily. The contrast between undiffused and heavily diffused graininess usually strikes a jarring note that's better to avoid.

Laura Bethel

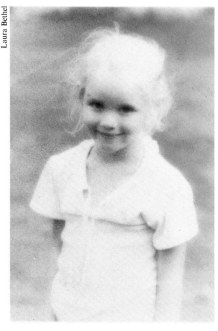

Straight print

Background highlights were burned in, revealing detail that existed in the negative.

Background highlights were flashed, surpressing distracting highlights.

FLASHING

Flashing means using raw light, unmodulated by the tones of a negative or positive, to darken or, if using reversal materials, lighten the print selectively. You can construct a good flashing device by taping a black paper cone over the reflector end of a small pen-type flashlight. Cut off the apex of the cone to form an aperture just large enough to let the flashlight cast a pool of light of a size suited to your needs. If the light is too bright, cover the aperture with one or more layers of translucent tape or with a small piece cut from a gelatin neutral density filter.

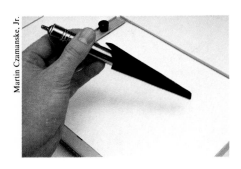

To make a handy flasher, add a black paper cone with the tip snipped off to a small flashlight such as a penlight. If the illumination is too bright to control print density easily, stick a few layers of translucent tape over the opening in the cone, or glue a piece cut from a gelatin neutral density (ND) filter on the tip.

Flashing in Black-and-White

Flashing is used often to darken distracting, bright highlights that would otherwise wrest attention from the true subject of the picture. For example, a small, glaring patch of light in a generally dark background of foliage would detract from the effect of an informal portrait. Flashing can darken that area quickly and easily.

If you're using a panachromatic material such as one of the KODAK PANALURE Papers, follow the procedures under **Flashing In Color**. With other black-and-white papers, you can try the following.

After making the basic, overall print exposure, plus whatever dodging or burning in may be required, swing the enlarger's red safelight filter below the lens and turn the enlarger light on again. With the projected image as a guide, use your flasher to paint light into the area that needs darkening. Move the light continuously as though you were burning in the area to blend the flashed section with its surroundings. Make a test strip or print first to determine how much flashing is needed to achieve the desired effect.

Flashing Versus Burning In

The major difference between flashing and burning in is that the latter is done through the negative or positive from which you are printing and the former is done independent of it. When darkening a highlight in which the film recorded some detail or texture, moderate burning in will reveal that image component. Flashing, which bypasses the photographic original, can only obscure detail.

This places a practical limitation on flashing when the final print will display noticeable graininess. Flashing will overwhelm the graininess in the flashed area, possibly creating a disturbingly smooth patch. In prints that don't exhibit pronounced graininess, skillful flashing can pass unnoticed.

Flashing in Color

You also can darken color prints from negatives and lighten reversal color prints from positives by flashing. But the process is a bit harder to manage because you don't have the luxury of a red-filtered, projected image to guide the flasher beam. Unfortunately, there is no color printing equivalent of a red enlarger filter.

However, you can process and dry a rough print, then carefully cut out the area or areas to which you wish to confine the flashing. If necessary, cut the flashing templates slightly oversize to permit blending the flashing with surrounding tones. Then expose another sheet of color paper for the final print. After the basic exposure has ended, place the cutout print in the easel on top of the just-exposed sheet of color paper. Flash through

Michael Donovan

Martin Czamanske, Jr.

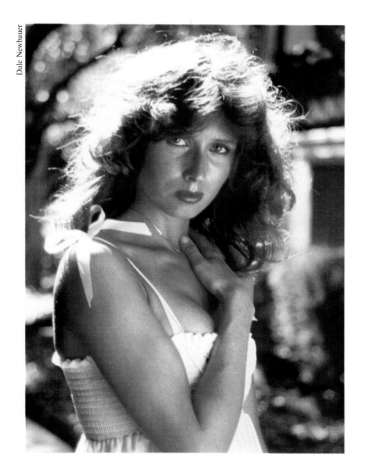

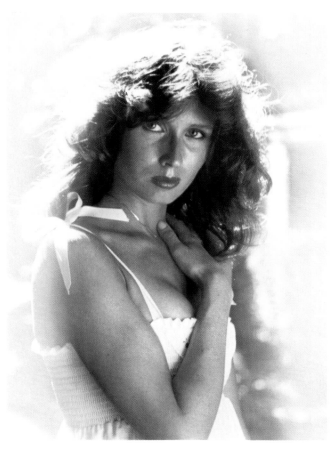

Straight print from a color slide, made with EKTAFLEX PCT Reversal Film.

*With EKTAFLEX PCT Reversal Film, flashing washes out the image to white or near white. For the flashed image, **above,** a cardboard cutout was cut into the shape of the subject and held about an inch above the film, **below.** Flash exposure was made by the enlarger with the slide removed. During exposure the cutout was kept moving to avoid a sharp edge between flashed and unflashed areas.*

the cutout portions. To blend the edges between flashed and unflashed areas, move the cut out slightly during the flash exposure. You may have to try more than once before producing the exact effect you're after because this isn't a very precise procedure.

Make test strips ahead of time to determine the proper filter pack through which to flash, unless your intent is to flash for maximum black or white. When attempting to color-flash an area to blend with surrounding hues, or to show whatever color you prefer, you will have to determine a filter pack for the flash exposure. You can hold either acetate or gelatin

filters in front of the flashlight, since the optical quality of the filters is irrelevant when you're not actually projecting an image.

Flashing for Effect
The preceding discussion of flashing was based on its use to enhance a conventional image. Don't overlook the potential flashing offers for virtually painting with light. You can use it to create surreal effects, for example, by flashing shadows on the wrong sides of objects, or washing unexpected colors into parts of otherwise familiar-looking scenes. Flashing can be an interesting vehicle for your flights of fancy.

Keith Boas

INTENSIFICATION

Intensification is a chemical process for increasing density and contrast of black-and-white film negatives and positives. Generally it is used to salvage negatives with insufficient density to print acceptably. Image intensification may be accompanied by increased graininess. And while intensification can increase the printability of weakly recorded details, it cannot increase detail in parts of the image where none exists.

Because of the additional handling and chemical treatment involved, which pose some risk to the film, observe the following precautions:

1. Make the best possible print from a negative before treatment.
2. Treat one film frame at a time.
3. Make sure original film processing included thorough fixing in an acid hardening fixer such as KODAK Fixer, followed by thorough washing. If in doubt, refix and rewash the film before intensifying.
4. Wear rubber gloves and observe any other handling precautions recommended by the manufacturer or publisher of a formula.

INTENSIFYING FILM

Intensifiers are available as packaged products, such as KODAK Chromium Intensifier, and as do-it-yourself formulations you compound from photographic chemicals. *Processing Chemicals & Formulas for Black-and-White Photography*, KODAK Publication J-1, presents formulas for four different intensifiers. The following comments apply to KODAK Chromium Intensifier, which may be obtained through photo dealers in packets to make 16 ounces (473 mL). It offers the advantage of producing little change in image color, and you can repeat the process if you decide you want more intensification. All operations may be performed in artificial light or subdued daylight. Solu-

Intensifying the negative in KODAK Chromium Intensifier added enough density and contrast to allow making a satisfactory print. Note that

intensification added density only where some was already present. It did not magically create detail where the film had recorded none.

tion and wash temperatures should be about 68°F (20°C).

1. Mix the contents of the chemical packets as directed to produce 16 ounces (473) mL) of each solution.
2. If the film is dry, soak it in clean water about 10 minutes. Handle only by the edges because intensification works on fingerprints left on negatives too.
3. Immerse the film in the Bleach Bath for 3 to 5 minutes until the black image areas are bleached yellow. Agitate the film during this entire step.
4. Rinse the film in fresh water.
5. Agitate the film continuously in the Clearing Bath about 2 minutes until the yellow stain disappears and a nearly white negative image remains.
6. Rinse the film in fresh water for 30 seconds.
7. Redevelop the film, agitating it continuously in KODAK DEKTOL Developer diluted 1:3, until the white image is completely darkened. No fixing is necessary.
8. Wash the film for 10 to 20 minutes in fresh running water.
9. Treat the film with a wetting agent and dry it.

If greater intensification is subsequently desired, you can repeat the entire process.

26

REDUCTION

Reduction generally refers to a chemical process for reducing the density of a black-and-white negative or print. It may be applied overall or limited to specific areas. Overall negative reduction is usually employed to salvage negatives that have been fogged, overexposed or overdeveloped to the point that they cannot be printed acceptably. Prints are often reduced locally to lighten selected areas for improved appearance. Overall reduction of prints is possible, but it is usually easier simply to make another print than to reduce one that is too dark. Besides chemical reduction, abrasive reduction is sometimes used for local treatment of large-format negatives.

Reducing Black-and-White Negatives

The cautionary notes regarding intensification on page 26 apply even more strongly to negative reduction. When you reduce a negative, the image detail lost is lost forever. The key to successful image reduction with negatives and prints is to proceed slowly and repeat the process until you have achieved the desired effect. Although reduction is not a game of chance, keep in mind the gambler's classic admonition: *Quit while you're ahead.*

KODAK Farmer's Reducer is a convenient, prepared reducer available through photo dealers in packets to make 1 quart (946 mL). *Processing Chemicals & Formulas for Black-and-White Photography,* KODAK Publication J-1, also presents formulas for eight different reducers you can mix for specific needs. The following discussion centers on KODAK Farmer's Reducer because of its general usefulness and availability.

USING *KODAK* FARMER'S REDUCER ON FILM

Farmer's Reducer removes equal quantities of silver from areas of high, medium and low density. You can observe the degree of reduction during treatment, which is done in normal room lighting.

1. Prepare the two basic solutions as directed and store them in separate containers until immediately before use, as the working solution deteriorates rapidly once mixed.
2. Mix equal parts of Solutions A and B to make a working solution. Mix only the amount you need because it is active for only 10 to 15 minutes after mixing.
3. Soak dry film for 10 minutes in clean water.
4. **For overall negative reduction:** Immerse the negative in a light color tray of full-strength working solution. Rock the tray continuously while watching the negative closely. Reduction occurs rapidly. Remove the negative as soon as you judge the reduction sufficient and proceed to Step 5.

 For local negative reduction: Dilute the working solution 1:4 (1 part working solution to 4 parts water) and apply it with a cotton swab to the area to be reduced. Rest the wet negative, emulsion up, on a sheet of glass or in the bottom of a light toned tray, or place it on a lightbox, taking care that no liquid leaks into electrified areas. Use cotton dampened with water to remove excess liquid from the area to be reduced. Alternately apply reducer with the swab; then wash it away with water-dampened cotton until the desired reduction is reached.
5. Wash the negative for 1 minute in running water.
6. Inspect the negative critically. If more reduction is necessary, repeat Steps 4 and 5.
7. Fix the negative for 5 minutes in an acid-hardening fixer.
8. Wash the film for 20 minutes, or use KODAK Hypo Clearing Agent to reduce the wash time.
9. Treat the film in diluted PHOTO-FLO Solution and dry it conventionally.

Abrasive Reduction

For reducing small areas of large negatives, you can use KODAK Abrasive Reducer to mechanically remove excess image density from the emulsion. It is supplied in ready-to-use paste form in jars containing 1/2 ounce (14.2 grams).

1. Tape the dry negative by the edges, emulsion up, to the glass panel of a lightbox.
2. Pick up a small quantity of Abrasive Reducer on a cotton tuft or swab and work it into the cotton by rubbing it against a slick surface, such as that of a glass plate.
3. Rub the charged cotton against the negative area to be reduced. Work slowly to avoid removing too much density.
4. After reaching the desired extent of reduction, remove remaining traces of Abrasive Reducer from the negative by cleaning it gently with a clean puff of cotton.

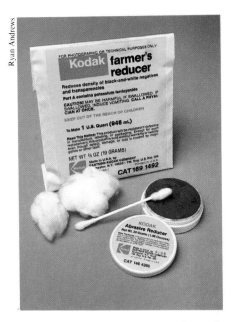

Farmer's Reducer (liquid) can be used with negatives and prints. Abrasive Reducer (paste) is for reducing small areas of large negatives.

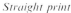

Straight print

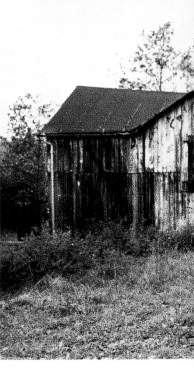

Farmer's Reducer was applied selective to lighten the center of the building an the downspouts at its corners.

REDUCING BLACK-AND-WHITE PRINTS

If you have black-and-white prints that are slightly too dark, you can use Farmer's Reducer overall to lighten them and clean up veiled highlights. You also can use local reduction to lighten parts of the image.

Prints to be reduced should be properly fixed and washed but not toned. If they have been dried, soak them in clean water approximately 10 minutes prior to reduction. A print that has undergone overall reduction may be toned later, but will not tone the same as another print made on the same paper without reduction. Don't try to tone prints that have been reduced locally as the toner will

affect the reduced areas differently from areas that were not reduced. As with negative reduction, print reduction is a room-light procedure.

1. Prepare a working solution of Farmer's Reducer by mixing equal parts of Solutions A and B; then further dilute the mixture with water as follows: 1:10 for overall reduction and for local application to brighten highlights, 1:4 for local reduction of darker areas.

2. To reduce overall density, soak the print in diluted reducer in a tray for 5 to 10 seconds with continuous agitation. To lighten small areas, apply reducer with a damp cotton wad, swab, or fine-tip artist's brush—first sponging excess

surface moisture from the print emulsion to prevent the reducer from weakening too fast or running.

3. Place the print on the back of a clean tray or heavy glass or plastic sheet tilted in the sink and rinse it in running water about 68°F (20°C), and observe the progress of reduction.

4. Repeat Steps 2 and 3 as necessary to achieve the desired effect, bearing in mind that the process will continue, although at a greatly reduced rate, for a short time during the following two steps.

5. Rinse the print in running water for 1 minute.

28

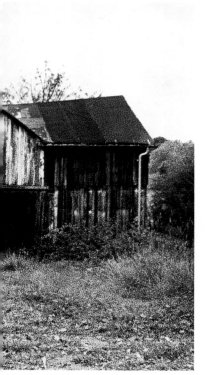

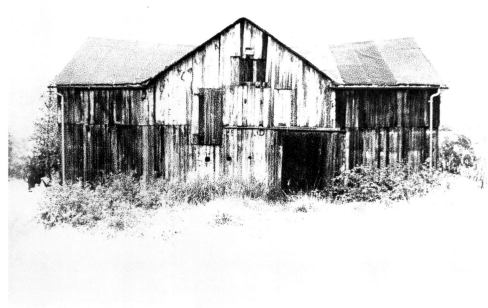

Here the entire print was bathed in Farmer's Reducer after local reducing bleached away background and foreground areas.

6. Fix for 5 minutes in an acid-hardening fixer.
7. Wash the print for 1 hour or use KODAK Hypo Clearing Agent as directed to reduce the wash time.
8. Dry the print normally.

Practice, Practice, Practice

Although it's basically easy to use most reducing agents, using them well and predictably requires familiarity that goes beyond simply following directions. Practice on scrap negatives and prints until you develop a feel for the way the reducer affects specific materials you use. And in the case of negatives, verify your impressions by actually making prints to see if the enlarging paper agrees with your visual estimate. Above all, learn to quit while you're ahead.

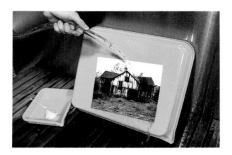

After each application of reducer, rinse the print with running water at about 68°F (20°C). Then inspect the treated area closely. Frequent, brief applications of reducer facilitate precise control of density and lessen the risk of excessive bleaching or staining.

Adding color

by Michael Bright

Turn your black-and-white prints into colorful pictures by toning or hand-coloring. By varying your technique and choice of materials, you can be as realistic or as abstract as you please in creating expressive, color-embellished photographs.

Unusual color prints can be created from black-and-white prints using transparent oils such as Marshall's photo-oil colors.

Sylvia Lizama

A few decades ago, before the existence of acceptable color processes, the only way of producing a color photograph was to hand-color a black-and-white print. Today there is renewed interest in hand-coloring and other techniques used to add color to black-and-white prints. Movie posters, record album covers, magazine and book illustrations, product ads, calendars and photo decor works of art are among the many popular applications of hand-coloring.

You can use many techniques and materials to add color to black-and-white prints, from selective application of special oils to overall baths in chemical toners. A variety of existing color effects can be obtained that are not possible with conventional color printing processes. You can transform an ordinary, black-and-white print into a realistic full-color print using products such as Marshall's photo-oil colors. Or you can tone the same print using commercially prepared or home-made toners, transparent dyes, water colors, food colors, coffee, tea or felt-tipped marking pens.

A major advantage of hand-coloring or toning your own prints is that you have total control over the application of every color. You can hand-color or tone the entire print to varying amounts of saturation and color. Or you can selectively color only those elements in the photograph that you want to emphasize.

To create this surrealistic study, titled Two Flocks of Flaming-O's, several techniques were applied:
1. *The print was selectively toned in KODAK Rapid Selenium Toner to color the birds. (See SELECTIVE TONING on page 34.)*
2. *Then a bath in Edwall green toner was used to selectively tone the background.*
3. *The print was selectively toned next in Berg copper toner to create a duotoned background.*
4. *Martin's transparent water colors then were used to touchup and emphasize some areas.*
5. *Finally, thread was stitched into the print to outline the birds, and decals were applied.*

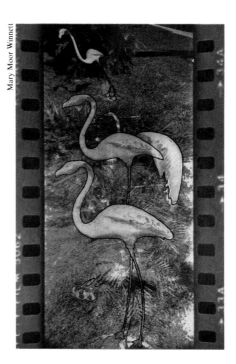

Mary Moor Winnett

Michael Bright

You can add striking impact to the subject of a black-and-white photograph by selective hand-coloring. Here KODAK Retouching Colors were used to emphasize just the important elements.

PREPARED TONERS

Toning prints chemically is a relatively simple way to add color to black-and-white prints. It's a popular technique used by many photographers to transform ordinary black-and-white prints into unusual color photographs. Toning is also used to create moods in a picture and to recreate the atmosphere of the original scene.

The chemical toning of prints works by converting the black silver image into a color. You can tone the entire print at one time or use selective toning in stages to add multiple colors. The process takes little time and can be performed under normal room lighting. Also, the chemicals are usually premixed so that only dilution with water is required.

There are several prepared toners made by Kodak and others which are available from photo dealers. Kodak toners include KODAK POLY-TONER, KODAK Brown Toner, KODAK Rapid Selenium Toner, and KODAK Sepia Toner. Each toner has its characteristic hue and produces variations of its original color when used with different papers. In addition, POLY-TONER produces different brown hues according to the dilution used.

In general, warm-tone papers usually tone more quickly and to a greater extent than cold-tone papers.

If you are interested in converting your black-and-white images to more exotic colors and would like the option of tinting the entire print, including highlight and border areas, try some photo toners that contain organic dyes. One kit that is available

through camera stores is manufactured by Berg Color-Tone, Inc. The kit offers liquid toners in colors which include two different hues each of blue and red plus violet, green, and yellow. By mixing together various toner combinations, you can achieve an even greater variety of colors.

Other Berg toners, such as the brown/copper solution used on page 33, produce subtle posterization/solarization effects when the toned prints are partially redeveloped. You must use a very dilute print developer (1:4 or more) and quickly remove prints from the developer as soon as gray midtones begin to appear. Immediately immerse the prints into a stop bath to halt the process. Otherwise, all the tone will disappear, leaving the original image.

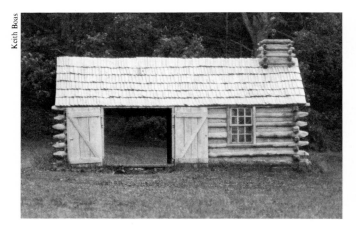

Untoned print

POLYCONTRAST Rapid II RC Paper toned with KODAK Brown Toner.

POLYCONTRAST Rapid II RC Paper toned with KODAK Sepia Toner. The resulting tones reinforce the warm mood established by the late-day sun.

Robert Clemens

Untoned print on POLYCONTRAST Rapid II RC Paper

Print toned in Berg copper toner for 10 minutes, washed for 30 seconds, then redeveloped for 30 seconds in DEKTOL Developer, diluted 1:4. Partial redevelopment produced slight posterization consisting of black, copper and copper-gray tones. As some bleaching of highlights occurs during redevelopment, exposure was increased 25%. After redevelopment, the print was put into stop bath for 30 seconds, then washed for 4 minutes.

TONING PROCEDURES

Using KODAK Toners

Make several copies of the prints to be toned so that you can experiment as you proceed. To avoid stains due to insufficient fixing or washing, use fresh fixer. Fix prints for the recommended time. Next wash prints thoroughly. Wash fiber-based prints for one hour or use KODAK Hypo Clearing Agent followed by a shorter wash time. The

clearing bath not only reduces the wash time, but also removes residual chemicals so that your toned prints will have cleaner, whiter highlights. If your prints are dry, soak them in water for 10 minutes, submerge them into the toning bath, and agitate until they reach the desired color saturation. Remove prints from the toner and rinse and dry them in the usual way.

Image Stability

KODAK Toners have been found to add to the life of a print, protecting the silver image against the effects of harmful gasses in the air. For more information on techniques for image stability, see the Kodak publications *Quality Enlarging with KODAK B/W Papers* (G-1) or *Preservation of Photographs* (F-30).

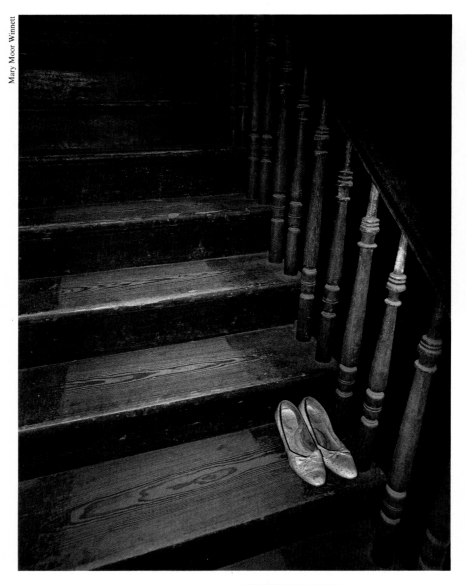

Mary Moor Winnett

Untoned print

This print was selectively toned three times. Before toning, the area surrounding the shoes was covered with frisket to protect it from the toner. After the print was toned in blue toner, the frisket was rubbed away. Fresh frisket then was applied to the shoes. Next the print was sepia-toned to color the background. A final toning in Berg copper toner added a reddish tint to the sepia-toned background. Finally, the frisket was removed from the shoes.

SELECTIVE TONING

Selective toning produces two tones on the same print—the normal image tone of the paper in areas you've selected and a second tone in the remaining areas. With this technique, you must cover the areas of the print that you do not want toned. This technique of toning is an excellent way to separate the foreground from the background as in a seascape scene or accent a center of interest in a complex composition.

MATERIALS
Photo Maskoid Liquid Frisket or rubber cement and thinner (available at most art supply stores).
A fine, narrow paint brush.

TECHNIQUE
Apply the rubber cement or frisket in two or three coats to the areas of the print not to be affected by the toner. To minimize the risk of having the toner creep under the edge of the covered areas, place the coated, dry print directly into the toner. Agitate the tray continuously to make sure the toner is kept flowing evenly over the uncoated areas. After toning, wash the print as recommended and then remove the rubber cement or frisket material. You can easily remove the coating by rubbing your fingers across it while the print is still in the wash or by using pieces of sticky tape after the print is dry.

Derek Doeffinger

Michael Donovan

The use of food colors for toning prints is a simple and inexpensive way to add excitement to ordinary black-and-white prints.

Even coffee or tea can be used as an inexpensive color toner. POLYCONTRAST Rapid II RC Paper toned for 10 minutes in normal-strength (drinkable) coffee at room temperature.

HOMEMADE TONERS

You can obtain color effects by using homemade toners made from food colors, coffee and tea. Unlike conventional toners, which give clean highlights and borders, these home-made toners produce an overall tint. You can make a pastel color by putting 10–20 drops of a liquid retouching watercolor in a tray of water and soaking the print in it until you achieve the desired effect. Or you can tone a print by soaking it in a normal brew of coffee or tea. After toning, give the print a quick water rinse and dry in the usual way.

Food colors are, perhaps, the most versatile materials found in the home for making your own toners. Materials needed include artist's brushes, bottle of white vinegar, print trays, and of course the food colors them-

selves. You will need to work near running water so set up the necessary trays in the area you normally wash prints. Prepare the toning solutions by adding 10–20 drops of the desired food color to a quart or litre of warm water with about 2 tablespoons of vinegar. The vinegar helps the food colors adhere more easily to the print. The color intensity can be varied by adding more or less food color to your toning solution.

To begin toning, submerge the print into the toner and agitate until you obtain the desired color saturation. Then remove the print and give it a quick rinse in cold, running water before drying it. When toning resin-coated prints in this way, hold the base side of the print under running water until all color is removed from the back of the print.

Prints can be multitoned with food colors by using a small brush and coloring one area at a time. Blot dry each area toned before applying the second and remaining colors. Repeat this procedure until you have applied all colors desired to the print. At this point, blot the entire print dry, give it a quick rinse in cold water, and dry it. To make the colors more stable, spray the print with a protective lacquer spray.

TRANSPARENT WATERCOLORS AND FELT-TIPPED PENS

Transparent watercolors and felt-tipped markers also can be used to add color to black-and-white prints. You can use a variety of watercolors to color an entire print or simply to accent a particular area within the print. This latter method is recommended for beginners since the first method is more demanding and normally used only by advanced colorists.

When using watercolors, it is usually best to dampen the print surface first with a cotton swab soaked in water. This allows the watercolors to be absorbed evenly on the paper surface. Use a brush on small, detailed areas and cotton swabs on larger areas. You can build up color saturation by applying several layers of color to the same area. Brush-applied transparent watercolors or felt-tipped pens work effectively in small, detailed areas of a print where you want to add color for impact.

Mary Moor Winnett

After this print was selectively toned with Rapid Selenium Toner to add warmth to the walls and candles, watercolors were applied with a fine brush to accent areas of interest.

Felt-tipped marking pens also can be used to add dramatic color to the main areas of a print.

Dan Ruhlman

KODAK RETOUCHING COLORS

These dry-cake dyes are excellent for applying light colors to large areas of black-and-white photographs. To apply a dye to a print, breathe on the cake of dye which you plan to use and then pick up a sufficient amount of the dye by rubbing a tuft of dry cotton over it. Transfer the cotton tuft to the print and begin rubbing gently. Next rub the cotton in a circular motion on the desired area of the print. Buff the area with clean tufts of cotton until the dye is evenly applied. You can remove unwanted dye from surrounding areas in the print by applying some of the reducer, which comes with the kit, to those areas with another clean tuft of cotton. A cotton-wrapped skewer or Q-tip can be used to clean off small areas adjacent to the colored areas. After wiping off the reducer, make the dyes permanent by holding the print over steam (boil water in a pot or use an inexpensive vaporizer) until the surface marks caused by the dye application disappear. If it is necessary to increase the density of the color saturation, add more dye to the area and steam the print again. You can repeat this procedure until you have obtained the desired color saturation.

KODAK LIQUID RETOUCHING COLOR SET

Designed for retouching color prints with a brush, these ready-to-use colors also work well for hand-coloring rather small areas on black-and-white prints. You can apply them with a brush or cotton swabs to fiber-base or RC papers. If you don't like your results, just soak the print in running water for a few minutes to dissolve away the colors. Then redry the print and begin again.

With dry-cake dyes, you can add subtle colors to black-and-white prints.

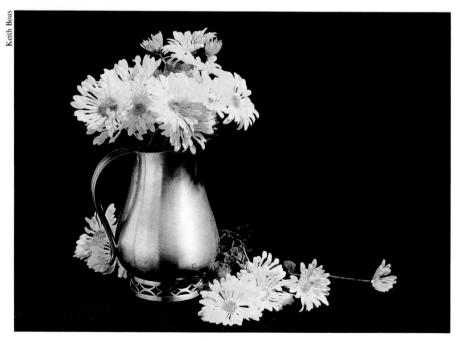

Liquid Retouching Colors, applied full strength with a fine brush and cotton swabs, gave life to the flowers in this black-and-white still life.

Transparent oils, meticulously applied to parts of the image, gave the scene a bright and gaudy presence.

Untoned print on POLYCONTRAST Paper, N Surface

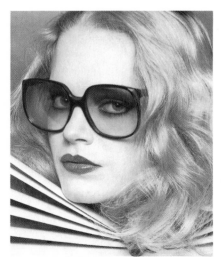

A selectively hand-colored print on KODAK MEDALIST Paper, G surface, using Marshall's photo oils

HAND-COLORING PHOTOGRAPHS WITH TRANSPARENT OILS

Ever wonder where the old color photographs of Garbo and other movie stars came from? Or have you ever been curious about the early color portraits of you or your parents? Most likely they are hand-colored photographs. The technique is an old one which has regained much popularity in recent years.

Hand-coloring photographs offers additional creative outlets for those of us who want to go beyond conventional color printing techniques. From realistic results to bizarre effects, color can be added to black-and-white prints in nearly any man-

ner. Hand-coloring gives you complete control over every color in a print. You can be as interpretative as you like in coloring the details in a print, regardless of their original color, or you can limit color to only the special areas you want to emphasize.

This technique of adding color to black-and-white prints offers countless creative possibilities since you often can surpass the results obtained from direct color printing methods. Practically any one can become a photocolorist. The technique is easy to master, and the results are nearly always pleasing on your very first attempt.

Here transparent oils were applied in contrasting hues to the entire black-and-white print to emphasize boldly the simplicity of the composition.

Sylvia Lizama

Papers

All photographs to be hand-colored should be printed on a matte surface paper. If you prefer using a resin-coated paper, select the N surface. With fiber-based papers, the G, N, and R surfaces are all good choices. Your choice of paper surface depends primarily on the subject matter in the photo. Duller surfaces such as the N surface absorb the colors better and are better suited to commercial products, landscapes, and any other subject that would generally be enhanced by stronger color saturation. In general, the duller the paper surface, the greater the color saturation.

Although any size print can be hand-colored, it is usually best to work with 8 x 10-inch or 11 x 14-inch prints. Print quality is also important. For example, an unsharp or grainy print will also be grainy and lack sharp detail after hand-coloring because the paints are transparent.

Experiment with a few different papers before limiting your hand-colored prints to just one paper type as each type will produce different effects. Color hues of the paint will differ slightly on different papers due to the varying tonal properties of each paper type.

Optional Sepia-Toning

Many photocolorists prefer to sepia-tone prints prior to coloring them, but this step is not necessary. Brown or sepia images, being less dense, reveal more color saturation than black-toned images. You also can obtain warmer flesh tones by sepia-toning the print first. However, the stronger contrast of some black-and-white prints which are hand-colored without toning often is more dramatic. If you don't first sepia-tone the prints you want to hand-color, make them a little lighter than normal in the shadow areas as the transparent oils reveal very little color in the darker areas.

PROCEDURE FOR USING MARSHALL'S PHOTO-OIL COLORS

Tape the print to be hand-colored onto a clean, smooth surface in a well-lighted area. Clean the surface of the print with Marlene (a cleaning liquid which comes with the Marshall kit). Next apply a thin coat of P.M.S. (prepared medium solution which also comes with the kit) using a wadded-up piece of tissue. Rub the solution thoroughly into the paper surface and then remove any excess solution with a fresh tissue. NOTE: When using resin-coated papers, you can either omit the P.M.S. step altogether or mix a little turpentine with the P.M.S. to reduce the oil base of the medium. When using duller surface papers (all non-RC papers), leave more of the P.M.S. on the surface because the medium will help the paints blend more easily.

Assuming your first attempt at hand-coloring is a portrait subject, begin by applying Marshall's flesh color to the flesh areas of the print. Always paint the face first. For landscapes or other subjects, begin with the sky or at the center of the print and work away from the center.

Apply paint to the photo sparingly using Q-tips or similar cotton swabs. Color large areas with cotton swabs and detailed areas with cotton-wrapped skewers or toothpicks. Blend the colors on the print surface in a circular motion. It is important to keep using fresh tissues or cotton when blending the paints to blend the colors evenly. When the flesh tone is close to being the desired shade, apply flesh shadow to the shadow areas of the skin and blend it in the same manner.

Leave the colors darker than you will ultimately desire until all colors are added to the skin area and clothing areas. Hand-coloring is both an additive and a subtractive process in that you begin with no color and, after adding color to the print, you gradually remove the color until you reach the desired hue.

Next apply lip color or lipstick color to the lips and carefully blend it using a cotton swab. Then add appropriate eye-shadow color in the same way if your subject is wearing eye make-up. Blend the flesh areas carefully toward the lips and eye-shadow areas; and conversely, blend the lip and eye-shadow areas toward the flesh areas. Add more flesh

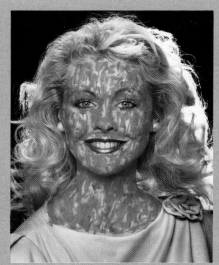

Original black-and-white print on POLYCONTRAST Rapid II RC Paper, N surface

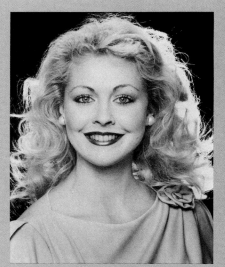

Flesh color applied to skin areas with cotton swab.

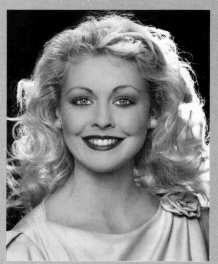

Lip and eye shadow blended; gum color added; teeth and white area in eyes cleaned; eye color added; and cheek color added

Hair color added, and eyebrows and eyelashes darkened

tone if necessary. When properly blended, remove the paint from the eyes and teeth using extender (part of the kit) on a cotton swab. Be sure all extender is removed from these areas by carefully rubbing fresh cotton swabs over the areas.

Next apply the appropriate color to the eyes and blend the paint. Be careful to use very little paint here or you will

have to reclean the white area of the eyes. A little cheek color can then be added to the cheek area and blended. Next add a little black or verona brown to the eyebrows and eyelashes and blend the colors carefully. You can then complete the face by adding the appropriate hair color and blending the color carefully toward the skin area. At this stage, any last-minute additions or

Flesh color blended using tissues and cotton swabs

Lip and eye-shadow color applied with cotton-wrapped skewer

Blouse color added

Background area cleaned with extender. The final, hand-colored photograph.

either can be cleaned off or painted any color you desire. If you decide to leave the background as it appears in the original photograph, clean off the background using P.M.S. to remove most of the unwanted background color. Then use extender, which won't run on the print, as you work nearer to the painted areas. To paint the background, apply your choice of color to the background and blend it with cotton tufts.

If you're not satisfied with your results, you can remove the paints during the first 24 hours or so after application by rubbing P.M.S. to the print and wiping off the paint.

If you are pleased with the results, allow at least two days for the paint to dry. A protective spray such as McDonald's Pro-tecta-cote can be used to make the colors last longer.

Although the Marshall Company provides many different hues, you may wish to mix some of your own specialized colors. It is always better to mix paints prior to application because mixing on the print surface may produce muddy colors. You can paint a print in several stages over several days. However, if you do not finish the coloring at one sitting, make sure that all colors that have overrun their intended borders are cleaned off and that all colors that are to be superimposed are already applied to the print.

The average photograph usually will take from $1/2$ to 2 hours to hand-color. Some prints with difficult subject matter can take up to several hours to complete.

MATERIALS

Special photo coloring oils such as the Marshall's photo-oil colors

Natural cotton (not synthetic)

Cotton swabs

Soft tissues

Small sheets of wax paper for blending paints

Marshall's photo painting pencils are also available and can be used for coloring small details. Marshall's photo-oil colors are available in kit form and include everything you will need to begin coloring prints. However, you eventually will need your own cotton and wax paper, as only limited supplies are furnished with the oils.

touch-up work should be made to the face. Accentuate skin highlights by rubbing the colors in the highlight areas. When satisfied with the face colors and blending, clean the highlights in the iris of the eye with a fine-tipped cotton skewer moistened with Marlene.

Next add clothing colors to the print. Be careful to keep the colors in their appropriate areas and out of the flesh areas. By beginning with the lighter colors initially, any overlapping of clothing colors can be covered by the darker colors.

Any jewelry with a silver finish should be cleaned with extender (part of the kit) whereas gold jewelry should be painted with raw sienna.

The background area of the print

Keith Boas

A color print made from a black-and-white negative and printed on EKTAFLEX PCT materials without using any filters or color mask

PRINTING BLACK-AND-WHITE NEGATIVES IN COLOR

Another technique for adding color to black-and-white images involves enlarging your original black-and-white negatives onto a color material such as KODAK EKTACOLOR Paper or KODAK EKTAFLEX PCT Negative Film. The resulting print will be one color, but it will show a range of tones of that color. Because these color materials are designed to be used with color negatives which have a built-in color mask, the mask is usually necessary for good color prints. Make the mask by having a piece of unexposed color-negative film processed. Place the mask in the filter drawer of your enlarger or tape it to the negative carrier above the negative. (See the photo on page 94.) Use this mask, together with your standard filter pack, in the enlarger whenever you are printing black-and-white negatives on color materials. Once the mask and filter are in place, simply print your black-and-white negative, just as you would any color negative. Process the paper or EKTAFLEX PCT Film in the normal way.

You can get saturated colors by printing through "sharp-cutting" filters. These filters transmit only one color of the spectrum, and they produce their complementary colors when used in conjunction with color printing material designed to work with negatives. Such filters and the colors they produce include:

KODAK WRATTEN Gelatin Filter	Resulting Color
25 Red	Cyan
58 Green	Magenta
47 Blue	Yellow
44 Cyan	Red
32 Magenta	Green
12 Yellow	Blue

42

Grant Haist

ADDING ADDITIONAL COLOR

When printing color negtives or slides, you can intensify or change overall color for a creative effect by manipulating your choice of printing filters. If you remove red (magenta plus yellow) filtration when printing a color negative, the resulting print becomes more red. With the appropriate subject, you can use this technique to enrich the tones of a sunset or create a late-day Alpine-glow mood where none existed.

Final print made without any filter pack in the enlarger. The absence of the 50 red filter pack has created warm tones, suggesting a sunset.

Original color print made from a color negative. The filter pack was 50 red.

Making high-contrast derivations

by Jeff Wignall

High-contrast films have the unique ability to reduce a normal, continuous-tone photograph to two distinct tones: solid black and white. By exploiting this basic capability, the inventive darkroom photographer can create a broad range of interesting abstract effects. Although practice is required to achieve predictable results, the techniques are relatively straightforward. The results are often bold and dramatic.

An apple tree on a bleak winter day is transformed, via high-contrast film, into an image similar to that of a pen-and-ink drawing.

Keith Boas

FILMS

High-contrast films represent an intermediate step between your original image and the final print. You can use both black-and-white negative and color-slide originals with equally effective results.

High-contrast films and developers are sold by graphic arts suppliers and at some camera shops. KODALITH Ortho Film 2556, Type 3, available in 4x5-inch, 5x7-inch and 8x10-inch sheet boxes is a popular choice and very convenient to use. The word *Or-tho* (short for orthochromatic) in the title means that the film is sensitive to blue and green light and not senstive to red light. Orthochromatic films can be handled safely under a KODAK 1A Safelight Filter (light red). The dim red illumination allows for much greater handling ease than working in the dark and enables you to watch developing progress.

KODALITH Ortho Film is also satisfactory for working with most color slide originals. However, if the slide you're using contains any amount of red subject detail that you wish to retain, use a panchromatic film. Panchromatic films, such as KODALITH Pan Film 2568, available in 4x5-inch and 8x10-inch sheet boxes, are sensitive to all colors and will record detail from red areas of the original. Although KODALITH Pan Film can be handled under a safelight equipped with a KODAK Safelight Filter No. 3 (dark green), the illumination is generally considered too dim for monitoring development.

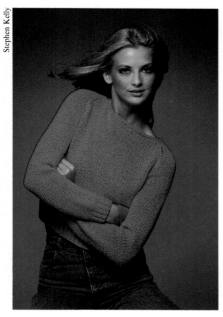

Stephen Kelly

Both a KODALITH Ortho and a KODALITH Pan Film negative were made from this original transparency. Prints from them appear on the right. Which KODALITH Film worked best? In this example, most viewers probably would prefer the image made from the ortho negative.

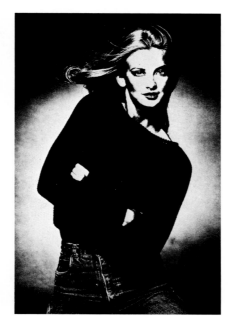

Print made from the ortho negative. The model's lips and red sweater have gone black, while the blue background recorded lighter.

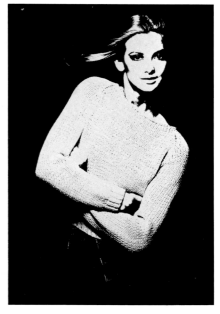

Print made from the pan negative. Red reproduced as white with some detail, while the blue background went black.

Donald Buck

KODALITH Ortho Film can be seen easily under suitable safelight illumination. (The emulsion side is the light-toned side). For this reason, it is not code-notched. Place the emulsion side toward your enlarger light source for exposure.

SUBJECTS

One of the secrets of early success in high-contrast image making is simplicity of subject. For your first experiments, choose original negatives or slides having subjects with strong lines and bold compositions. Although intricate compositions will sometimes create interesting images, simpler, more defined subjects lend themselves better to this type of work. Visualization—or picturing the finished photograph in your mind—also is easier from an uncluttered original.

Landscapes containing large areas of light and dark, or strong horizontal or vertical lines, are ideal. Symmetrical patterns, such as the contrasting highlights and shadows of modern architecture, also can be effective. Rough textures, as in weathered barn siding, are another possibility. For people pictures, isolated action figures (skiing, running, golfing, etc) offer the most potential.

Regardless of the subject, high-contrast film is quite honest about what it sees. Try to see as the film does, in terms of forms carved by highlights and shadows. With experience, you'll get a feel for which subjects will work the best.

Shadows from a lath roof, falling onto the photographer's legs, formed the primary pattern in this photograph. Mid tones were eliminated in the darkroom by making intermediate images onto high-contrast film.

Mike Gregan

D. Knight

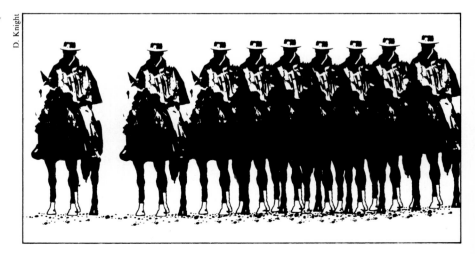

To create this pattern of repeated high-contrast images, the photographer made nine exposures from a high-contrast negative onto a single sheet of paper. After each exposure, the easel holding the paper was moved slightly in a horizontal direction.

M. West

Simple compositions, containing large expanses of unbroken light or dark areas, can make dramatic photographs in high contrast.

© Jeff Wignall, 1983

To make this high-contrast photogram, a collection of keys was arranged on a large sheet of glass under the enlarger lens. Next a sheet of photographic paper was slipped under the glass and exposed by turning on the enlarger lamp. Being opaque, the keys allowed no light to reach the paper and produced white (negative), high-contrast images of their shapes. (For more information on making photograms, see pages 86 through 89.)

EXPOSURE

To begin, you should decide what size high-contrast negatives or positives you want to make. If you plan to use them to make enlargements, make them the maximum size your enlarger's negative carrier will accept. Large sheets of film are easier to handle and retouch.

If you prefer (and it's required for some advanced techniques), you can make enlarged negatives or positives the same size as your final print will be. These images then can be contact-printed onto photographic paper.

You also can make contact exposures onto KODALITH Film from your originals in the same manner as you would make a standard proof sheet. In this way, you can gang-print several small originals onto one sheet of the film. This method is viable only if all of the originals have a similar density and tonal range.

To make enlarged KODALITH Film images, place the original in the negative carrier and compose the scene on the easel. Make a test-strip exposure, using three or four different exposure times. For enlarging a 35 mm negative to 4x5 inches, try test exposures of 5, 10, 15, and 20 seconds at $f/11$.

Exposure times will depend to a large extent on the density of the original, amount of enlargement, and brightness of the light source. Because this is a creative technique, acceptable exposure is mostly a matter of the effect desired.

DEVELOPMENT

Process the film in KODALITH Developer or Super Developer according to the data sheet supplied with the film. KODALITH Developer comes in two parts—A and B. These are mixed individually beforehand and stored in separate containers until use. The working solution is made up of equal amounts of A and B. High-contrast developers tend to weaken quickly as they're used, so it's best to work with small quantities and change to a fresh bath frequently.

Stop, fix and wash the film as indicated. You may notice that the clear areas of the film have a milky appearance during development. This will clear gradually during fixing. After the wash step, treat the film in diluted KODAK PHOTO-FLO Solution and hang to dry.

Far Left: The first step in making a high-contrast enlargement involves selecting the right image. Here a frame on a 35 mm film proof sheet was chosen because of its simple, graphic quality.

Left: The original, continuous-tone negative then was enlarged to 4 x 5 inches, the maximum format capability of the photographer's enlarger.

Keith Boas

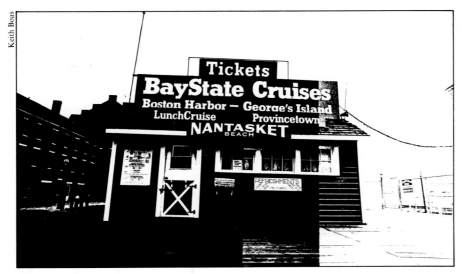

Left: To determine exposure for the high-contrast, intermediate positive, the photographer made a series of test exposures in steps on a sheet of KODALITH Ortho Film. This is how the film appeared after processing. From this test, he then chose the best exposure and used that time to make a workable high-contrast positive. To make a high-contrast negative, he contact printed the positive with a fresh sheet of KODALITH Film.

GENERATIONS

If you begin with a negative, your intermediate film will be positive. If printed at this stage, your final print would be a negative image. To get a positive image in your final print, simply contact-print your positive onto another sheet of high-contrast film. This will yield a high-contrast negative from which you later can make a positive print. These steps of flopping from positive to negative and vice versa, are known as making generations. You could, of course, go directly to a negative generation by starting with a color slide.

Keep in mind that you're working in an abstract medium, so you needn't feel constrained by the normalities of positive or negative in the final print. For example, if your newly created high-contrast image looks good in the form of a negative picture and accomplishes your goal, you can stop right there.

RETOUCHING

One of the appealing aspects of working with high-contrast films is that you easily can retouch unwanted details or background clutter. Backgrounds or fragmented subject parts, which might be recognizable and acceptable in a conventional print, may become distracting in high contrast.

KODAK Opaque is a thick blockout material which can be applied with a small artist's brush. It dries quickly and can be applied either to the base or emulsion of the film. Opaque is available in both red and black, though you may find it easier to follow your progress with the red.

Removing small areas of clear film is easy. Simply paint them away. To remove areas of density (black film), first reverse the generation by making a contact print onto another sheet of lith film. Now these details are clear and also can be painted away. You'll have to contact-print this film to

Keith Boas

KODALITH Negative made from a 35 mm color slide.

Positive print made from the KODALITH Negative.

*The series at the **right** shows how you can eliminate unwanted elements in a high-contrast picture by careful retouching with opaque. At the **top** is the original color slide. The print in the **center** was made from the unretouched KODALITH Negative. The print at the **bottom** was made after the negative was retouched. It displays cleaner lines and an uncluttered background.*

Kenneth MacKay

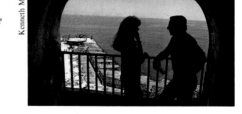

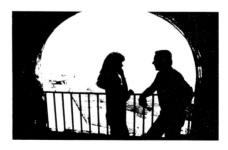

make a new generation to get back to the correct orientation.

High-contrast films also are notorious for attracting dust, which reveals itself as tiny clear specks in the black areas of the image. These "pinholes" will print as unwanted, black specks. If your original was a negative, you can retouch pinholes on the intermediate positive before contact-printing back to a negative generation.

For retouching large areas of clear film, you can use lithographer's tape. This material is opaque and comes in rolls of several widths.

MAKING SCREENED IMAGES

When a continuous-tone illustration is prepared for reproduction in a publication, it goes through a process called *screening*. The original is re-photographed through a halftone screen. This screen converts the original, continuous-tone image into a pattern of black dots and clear film. The size and closeness of these dots in the screened separation creates the illusion of gray values—similar to the way that cross-hatching does in a pen-and-ink drawing.

KODALITH AUTOSCREEN Ortho Film 2563 is a high-contrast film with a built-in halftone dot pattern and is intended for use in reproducing pictures on letterpress or offset printing presses. For creative applications, you can use the dot pattern of this film as a built-in texture screen.

AUTOSCREEN Film differs from normal KODALITH Film in use, in that it requires two separate exposures to achieve optimum quality for reproduction on the printed page. The first or *main* exposure is made in the same manner as you normally would print an original onto high-contrast film. However, to control the contrast, you need to make another exposure. This second or *flash* exposure is made by exposing the film, without the original, to the light of a KODAK OA Safelight Filter (greenish yellow). With the safelight 4 feet (1.2 m) above the film, use an exposure time of about 30 seconds with a 15-watt bulb behind the filter. The flash exposure is necessary to extend the tonal range *and* creates a minimal dot pattern in areas which received the least exposure during the main ex-

posure (highlight areas from a negative original or shadow areas from a color-slide original). In short, the flash exposure helps create a defined dot throughout the entire range of tones.

For creative work, the flash exposure is optional, depending upon the final effect you desire. No flash exposure was used to produce the photo below.

You can control the intensity of the AUTOSCREEN Film dot pattern in your final print by varying the extent of enlargement. An 8x10-inch enlargement from a 4x5-inch negative will have a mild pointillism effect. But an 8x10-inch enlargement from a small (35 mm) negative will be dominated by the dot pattern.

This print was created by first contact-printing the original 35 mm negative onto KODALITH AUTOSCREEN Film, which when processed yielded a halftone screened positive. Next the positive was contact-printed onto KODALITH Ortho Film to reverse the image back to a negative. This new negative then was enlarged onto photographic paper.

Robert Clemens

STRIPPING

Stripping is an assembly technique that allows you to create multiple-image prints from any number of negatives or positives. By using this method, you can create a composite negative of the montage.

Basically, you convert interesting sections of original negatives to high-contrast positives and arrange them into an imaginative composition on a print-sized sheet of clear acetate (available at art-supply stores). Next you make a working or stripped negative by contacting this layout onto a sheet of high-contrast film.

First determine what size the final print will be. Cut a piece of white artboard to this size and use it as a sketchboard to help plan your final design. Then gather a small group of original negatives and, in suc-cession, enlarge them onto the artboard. Trace the elements from each original that you think will combine for an interesting image. Using this tracing method will help you experiment with various proportions and arrangements without wasting film.

With elements and proportions decided, expose each original onto separate sheets of high-contrast film. Use your tracing as a sizing guide and use only enough film to contain the desired portion of the original. Process and retouch each positive normally.

Now cut a clean piece of clear acetate to the final print size. If there is excess film in any of the positives, carefully cut it away with scissors. Arrange the subject elements, emulsion up, on the acetate. When you're satisfied with the composition, tape it in place using small bits of transparent tape.

Expose this assemblage (emulsion-to-emulsion) to a sheet of high-contrast film in a contact-printing frame. This processed film is your stripped negative. Retouch the film to remove any pinholes or edge marks.

After KODALITH *Ortho Film positives of varying image magnifications were made from the same negative, excess film was cut away,* **top.** *The trimmed positives,* **bottom,** *then were arranged on a sheet of clear acetate and secured with transparent tape.*

To produce this final print, the taped composite was contact-printed to a fresh sheet of KODALITH *Film. After processing, the resulting stripped negative was retouched with opaque and printed onto photographic paper.*

51

MAKING TONE-LINE IMAGES

The tone-line process produces prints with the highly detailed look of an etching. There are several steps involved in this technique and achieving successful results requires practice and ingenuity.

The tone-line technique is, in effect, an edge drawing obtained by exposing a continuous-tone negative and positive, in register, onto a sheet of high-contrast film.

First make a continuous-tone positive from your original black-and-white negative, by contact-printing it onto another sheet of film. It's easier if you use a film such as KODAK Commercial Film 6127, which can be handled under a safelight. This positive should be similar to the original in tonality and density.

Visually register the two films (base-to-base) and tape them at the edges. Align this sandwich over a sheet of high-contrast film and place in a contact-printing frame.

Since both positive and negative images are in register, you must make the exposure with the light source at an angle. The simplest way to accomplish this is to suspend a frosted 100-watt bulb about 3 feet (0.9 m) above the contact frame, and off at an angle of about 45 degrees.

To get even coverage, expose either by rotating the frame (on a small turntable) or manually move the light source in a circular fashion around the frame. Experimenting is the only way to find the correct exposure time.

Process the film and use it to print your tone-line image. If you prefer a final print that looks like this tone-line negative, convert the image to a positive via one more contact-printing step onto high-contrast film.

Keith Boas

Original negative

Continuous-tone positive made by contact-printing the original negative with KODAK Commercial Film

To arrive at this tone-line final print, first the original negative was contact-printed onto KODAK Commercial Film to produce a continuous-tone positive. This positive then was sandwiched with the original negative and exposed to KODALITH Ortho Film in a print frame. The exposure was made at an angle to a light bulb as described in the text. The result was a high-contrast positive. Contact-printing this positive onto another sheet of KODALITH Film produced the high-contrast negative from which this enlargement was made.

Keith Boas

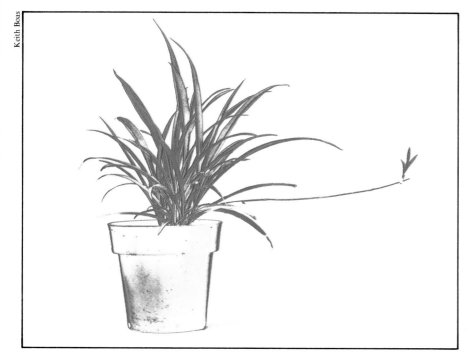

High-contrast film was used for all stages (except for the original PLUS-X Pan Film negative) in creating this tone-line. The final print from the positive/negative sandwich was made on EKTAFLEX PCT Negative Film. Two filtered exposures were made, using a 40-watt high-intensity bulb in a mini desk lamp reflector: **1.** 120-second exposure with the reflector's opening covered by a No. 33 magenta gelatin filter square. **2.** 40-second exposure with a No. 47 blue gel filter covering the reflector. The filtered exposures produced the green image with yellow undertones.

Eric Arvid Englund

When you create tone-lines, intermediate negative images often become successful photographs in themselves. The photographer took the original picture on an overcast day with PLUS-X Pan Film. Later he made both positive and negative generations from it with KODALITH Ortho Film. These two high-contrast images were sandwiched and exposed to another sheet of KODALITH Film, creating the line positive used to print this nocternal-mood photograph.

Continuous-tone positive
Original negative
High-contrast film

Turntable

100-watt frosted bulb

3'

3'

45°

Making posterizations

by David Engdahl

Posterization—an artistic technique of separating the tonal gradations of a photograph into clearly defined steps using high-contrast films. You can convert the image of any black-and-white negative, color negative or color slide into a graphic, posterlike illustration having sharp delineation of tones.

This posterization, derived from an original color transparency, was achieved by using a variation of the technique explained on pages 62 and 63.

Yuten Konishi

Joseph Tomassini

The simplest form of posterization is a two-tone (black-and-white) high-contrast print.

Jeffrey Sedlik

A four-tone posterization contains white, light gray, dark gray, and black steps.

POSTERIZATION—ITS VALUE

Simplicity is one of the most dynamic visual components used by successful commercial photographers and designers. They know that an illustration often can have its greatest impact when full gradation of tones are replaced with a limited number of flat tones. The subject, broken into its basic lines, shapes and colors, becomes a simple graphic expression of the original scene and, consequently, a more eye-catching portrayal. These qualities make posterizations popular in illustrating posters, book jackets, and certain product labels.

Posterizations are defined by their number of tones. High-contrast prints, those having just two tones (black and white), are the simplest of posterizations. Three-tone posterizations contain black (shadows), gray (middle tones) and white (highlights). In four-tone posterizations, the gray tone is broken into two steps—light gray and dark gray. When black-and-white prints are taken beyond four tonal steps, they begin to appear as continuous-tone images because tones are so close together. To make posterizations in color, you record the tones as different colors and control what those colors will be through your choice of printing filters.

THE TECHNIQUE

When you posterize a picture, you first make a series of high-contrast images (separations) onto a film such as KODALITH Ortho Film. These images then are printed in register—one at a time or in combination—onto photographic paper.

MATERIALS

Let's assume that you want to make 8x10-inch posterized prints in both black-and-white and color. Besides your normal darkroom equipment, here's what you'll need:

1. KODALITH Ortho Film 2556, Type 3, 8x10 inches (if originals are black-and-white negatives)

2. KODALITH Pan Film 2568, 8x10 inches (if originals are color negatives or color slides)

3. KODALITH Developer or KODAK Developer D-11

4. Standard paper or film fixer

5. KODAK PHOTO-FLO Solution

6. KODAK Opaque—for retouching the lith films. It comes in a 1-oz (30 mL) jar.

7. Retouching brush

8. Flat board and piece of plate glass with beveled or taped edges for safety. Both materials should be slightly larger than your film and paper.

9. Two register pins or a print frame with positioning guides

10. Two or three-hole paper punch

11. Masking tape or cement

12. No. 25 red or No. 29 deep-red gelatin filter.
No. 58 or No. 61 green gelatin filter. } for working with color originals
No. 47 or No. 47B blue gelatin filter.

13. Your usual black-and-white or color paper and chemicals

You also will need a device to hold the filters on your enlarger lens so that you can change them easily between exposures.

55

REGISTRATION

Later, when you print the intermediate, high-contrast positives and negatives onto photographic paper, you'll need a dependable method of keeping these films in register. *The images must fall exactly in line with one another for a sharp, final print.* Therefore, before going anywhere with this technique, you must decide how you want to handle registration. Here are two methods to consider:

Print-Frame Alignment

Project your original image onto a print frame or some similar device for holding the high-contrast film flat. If you are using a print frame, make sure that the frame and the sheet of film it holds are located under the enlarger exactly in the same place for each exposure. On the glass of the print frame, use strips of masking tape to produce an edge against which you can carefully position each unexposed sheet of film. How you position the frame itself under the enlarger depends on the style of print frame you own. You might find it practical to place heavy weights on the easel along the back and one side of the print frame. Then, if the alignment of the frame is disturbed each time you reload with a fresh sheet of film, you can butt the frame against the weights again for proper realignment prior to the next exposure.

Pin Register

For a better method of register, use register pins. They're available from drafting and graphic-arts suppliers. These pins are raised metal cylinders with a flat surface having the same diameter—1/4 inch (6.35 mm)—as the punch holes in a 2- or 3-hole paper punch. The pins have been fastened onto small, thin tabs of stainless steel for ease in handling and mounting on a flat board.

Punched film in register with pins

MAKING A REGISTER BOARD
Place the pins near the narrow side of a *flat* board. Plywood, pressed board, Masonite or a second sheet of dull-edged plate glass all will work fine. With your paper punch, make two holes in an 8x10-inch sheet of paper or old film. Place the film as shown in the drawing with the register pins in the two punched holes. Cement or tape the pin tabs in place. Remove the punched film. Now your registration system is ready to use.

BLACK-AND-WHITE POSTERIZATIONS FROM NEGATIVES AND SLIDES

To make an 8x10-inch, four-tone posterization from a negative: First pick a black-and-white negative of a subject that prints with a full tonal range (white, grays, and black) or a color negative with a full brightness range. For a posterization (final print) that will be visually acceptable, choose a simple, straightforward subject.

From this negative, you make three 8x10-inch high-contrast positives in register each with a different exposure. Use KODALITH Ortho Film with black-and-white negatives— KODALITH Pan Film with color negatives. From each of these resulting positives, you next make a high-contrast negative. You then contact-print each of these intermediate negatives individually, in register, onto a sheet of photographic paper to produce a four-tone posterization.

If the original image you want to posterize is a color slide, you can skip a step. With the slide in the enlarger, make three separate exposures onto three different sheets of KODALITH Pan Film. Because a color slide is a positive, you now will have three intermediate negatives. Contact-print each of these negatives individually, in register, onto your printing paper.

Keith Boas

*To make the posterization **above,** three KODALITH Pan Film negatives were made from the color slide **on the right.** Exposures were 2, 8 and 32 seconds with the enlarger lens at f/11. Each negative then was printed separately onto the same sheet of printing paper. Each exposure, being 5 seconds, provided an accumulated time of 15 seconds in areas where all three negatives were clear. This was enough exposure to produce a black in the printing paper.*

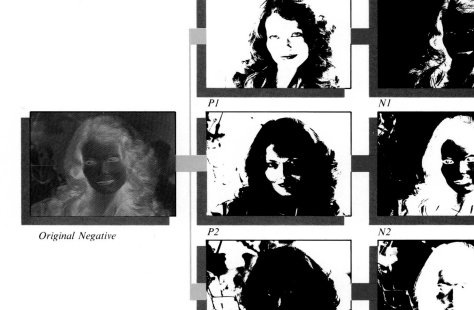

Original Negative

P1

N1

P2

N2

P3

N3

Four-Tone, Monochromatic
Posterization

MAKING THE SEPARATIONS

Punch an 8x10-inch sheet of white paper and place it onto the register pins. Project your negative onto this paper. Adjust and focus the image to a size slightly smaller than the paper. Remove the white paper and substitute it with a sheet of punched 8x10-inch black paper. The black paper will reduce the possibility of halation—extraneous light diffusing the image on the film.

In the dark or under the proper safelight illumination, punch a piece of KODALITH Film. Place it emulsion up on the register pins. The emulsion side is a lighter color than the base side. Place a second piece of plate glass over the film to hold it flat. Set your enlarger lens at $f/8$ and make a series of exposures. Try steps of 1, 2, 4, 8, and 16 seconds. Process the film according to its instructions. Now look for the exposure time where there is the first appearance of detail. This will be in the shadow areas of the positive, corresponding with the lightest parts of your original negative. Next make a full-sized 8x10-inch positive film at that exposure time. Expose two additional positives, quadrupling the time of each preceeding exposure. For example, if you exposed the first positive at 2 seconds, expose the others at 8 and 32 seconds.

Process the KODALITH Film positives normally. Be consistent. Use the same temperature and the same style of agitation each time. After your positives are completely washed, soak them for 30 seconds in a bath of diluted KODAK PHOTO-FLO Solution. Then hang them to dry.

There should be considerable density difference among the three images. After looking at the results, you may want to make another exposure or two at new times to produce greater differences among the images.

After the positives are dry, make a test exposure onto KODALITH Film from the densest (darkest) positive. You should see a minimum of tones in the resulting negative. Now contact-print all positives onto separate sheets of fresh film at that same exposure time. Process and dry these quite different looking negatives.

At this point, label the positive and negative films so that you will not get mixed up when using them later. Label them as follows:

Lightest (thinnest) positive	**P1**
Mid-density positive	**P2**
Darkest (densest) positive	**P3**
Darkest (densest) negative	**N1**
Mid-density negative	**N2**
Lightest (thinnest) negative	**N3**

Use the "N" KODALITH Films for making a posterization onto black-and-white paper. Use conbinations of both the "N" and the "P" films when printing color posterizations. (See page 60.)

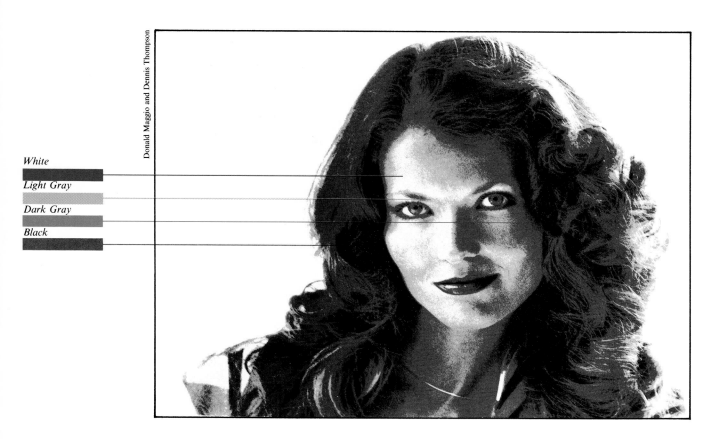

White

Light Gray

Dark Gray

Black

Donald Maggio and Dennis Thompson

PRINTING THE SEPARATIONS ONTO BLACK-AND-WHITE PAPER

1. Align the register board, with a punched sheet of white paper in place, within the illuminated area under your enlarger. Remove the white paper.

2. Under proper safelight illumination, make a test strip, using a piece of black-and-white enlarging paper.

3. Select the minimum exposure time that produces a good black.

 Your final series of steps will be to make separate exposures through each negative onto the same sheet of paper. As exposures will be cumulative, each negative should be given 1/3 of the exposure required to produce a black tone. For example, if a 15-second exposure produced a good black on the test strip in Step 2, use a 5-second exposure for each of the negatives. The result will be a build-up of density on the print, separated into distinct tones:

 White—areas receiving no exposure
 Light gray—areas receiving 5 seconds' exposure
 Dark gray—areas receiving 10 seconds' exposure
 Black—areas receiving 15 seconds' exposure

4. Under proper safelight illumination, punch a sheet of black-and-white enlarging paper and place it onto the register pins.

5. Make successive exposures using N1, N2 and N3. Process the sheet of paper and judge your results under normal room lighting. Make exposure adjustments according to your tastes.

Keith Boas

Posterization on EKTAFLEX *PCT Paper. Actual exposures, as indicated in the diagram, were made on* EKTAFLEX *PCT Negative Film. After processing, the image was transferred to the PCT Paper.*

Print from original black-and-white negative

PRINTING THE SEPARATIONS ONTO COLOR PAPER

You can use EKTACOLOR Papers or EKTAFLEX PCT Negative Film and Paper. Although the processes for these materials are considerably different, methods of exposure and the posterized results are nearly the same.

MAKING A POSTERIZED COLOR PRINT
Use a KODAK 13 Safelight Filter (amber) with a 7 1/2-watt bulb at least 4 feet (1.2 m) away from the color material. Make all exposures on your register board.

1. Make three tone-separation negatives and corresponding positives as described on page 58.

2. Place a sheet of unexposed, developed color-negative film in the filter drawer of the enlarger. Balance the paper to produce a neutral color, using standard CC or CP filters in the enlarger.

3. Using the filter of your choice, make a series of test exposures from the darkest positive (P3).

4. Make a series of test exposures from each of the three negatives (N1, N2 and N3). Use different filters with N2 and N3. But don't use a filter with the N1 exposure as this is the shadow record which produces black in the posterization. After processing the test print or prints, select and record the best exposure time for each negative and for the positive.

5. On a fresh sheet of color paper, print the darkest negative (N1) using the exposure determined above. (To simplify the explanation, paper is being used generically to mean either EKTACOLOR Paper or the intermediate EKTAFLEX PCT Negative Film.)

6. Remove N1 and replace it with the lightest positive (P1) and the mid-density negative (N2) in register. *Do not move the paper*. Print this combination through your selected filter, using the exposure determined for the mid-density negative.

7. Remove P1 and N2, and replace them with the mid-density positive (P2) and the lightest negative (N3) in register. *Do not remove the paper*. Print this combination through your selected filter, using the exposure determined for the lightest negative.

8. Remove P2 and N3, and replace them with the darkest positive (P3). *Do not move the paper*. Print this positive through your selected filter, using the exposure determined for the darkest positive.

9. Process the paper in the normal way.

Rikki Owen

Procedure for combining and printing tone-separation negatives and positives onto EKTACOLOR Paper or EKTAFLEX PCT Negative Film and Paper. The filters indicated here were used to expose the color posterization of the railroad tank cars.

The subtle, earth tones used in this posterization harmonize with the grasses, making the image a good choice for wall decor in a room having brown, gold, and green tones.

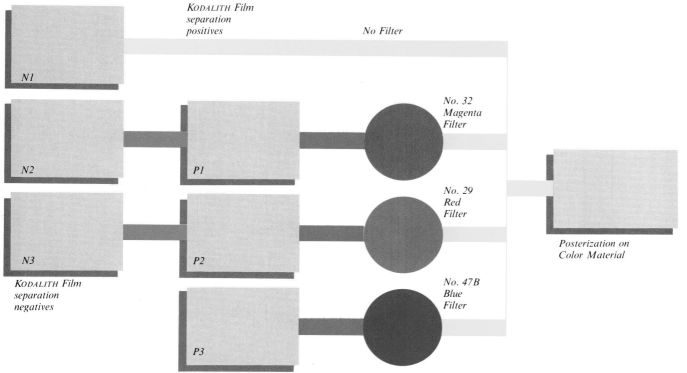

KODALITH Film separation positives

No Filter

N1

N2

P1

No. 32 Magenta Filter

N3

P2

No. 29 Red Filter

KODALITH Film separation negatives

P3

No. 47B Blue Filter

Posterization on Color Material

SEPARATING COLOR NEGATIVES AND SLIDES

The following steps illustrate another method for making color posterizations. Although more complex, the procedure does provide you with a vast number of film/filter combinations when making the final posterization print through buildup exposures. While the steps and diagrams indicate a color slide as the original image, you also can begin with a color negative.

1. Use register pins to keep the images aligned.

2. Make exposures onto two sheets of KODALITH Pan Film through blue and red filters. Process and dry the sheets of film. The results will be high-contrast separations.

3. Punch six fresh sheets of pan or ortho film. Make three contact exposures from the blue-filtered separation negative using different exposures as described on page 58. After you have processed the sheets, you will have a thin, a mid-density and a dense positive. Next

do the same with the other three punched sheets of KODALITH Film using the red-filtered separation negative. After processing all these sheets, you will have a set of thin, mid-density and dense positives from the "blue" separation negative and a similar set of three positives from the "red" separation negative.

4. Make contact exposures onto more punched KODALITH Film, using one standard exposure, to obtain six high-contrast negatives. Label all positives and negatives according to the chart to keep everything organized.

5. Print the positives and negatives individually or in any combination that you prefer through different filters.

HELPS!

1. *Cleanliness is important.* Dust or dirt on the original negative, positive or plate glass will carry through as spots in each step to the final posterization.

2. Careless workmanship will show in the final result. At that point, it's too late to make corrections.

3. Don't charge blindly into the technique unless you understand what is happening each step of the way.

4. Keep accurate notes in a lab notebook. Then you can later refer to what you did to produce a certain result.

5. You can modify any of the negatives or positives for artistic effects by adding opaque to any part of the image. (See page 49 for tips on using opaque for retouching and making image deletions.)

6. If you want a posterized photograph in a different size or in quantity without going through all the steps again, copy the finished print onto a continuous-tone black-and-white or color-negative film to produce a new negative. Use this copy negative to make future prints in the quantity and size you desire.

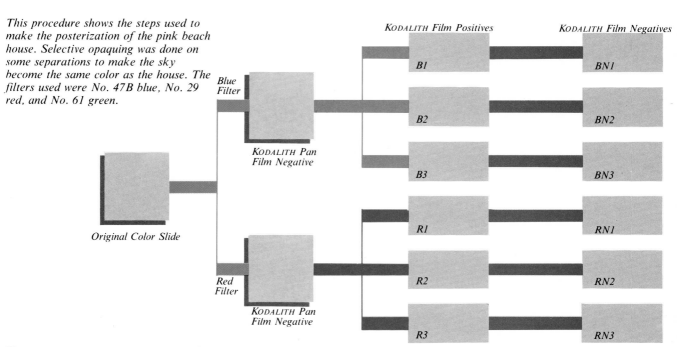

This procedure shows the steps used to make the posterization of the pink beach house. Selective opaquing was done on some separations to make the sky become the same color as the house. The filters used were No. 47B blue, No. 29 red, and No. 61 green.

Original Color Slide

Blue Filter

Red Filter

KODALITH Pan Film Negative

KODALITH Pan Film Negative

KODALITH Film Positives

B1

B2

B3

R1

R2

R3

KODALITH Film Negatives

BN1

BN2

BN3

RN1

RN2

RN3

Color posterization resulting from procedure described in the accompanying diagrams

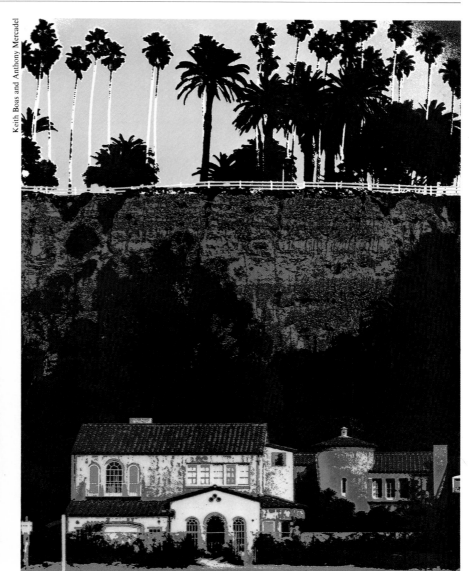

Keith Boas and Anthony Mercadel

Original color slide

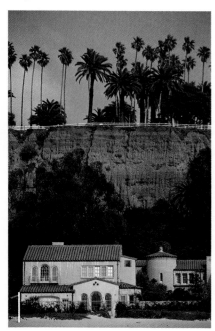

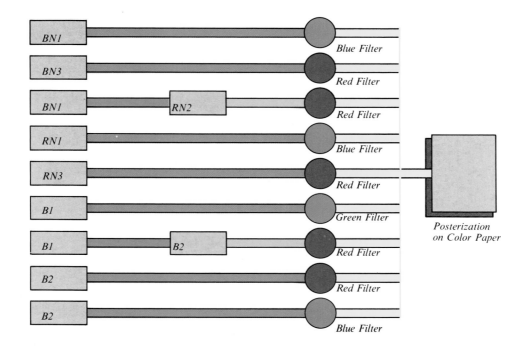

BN1 — Blue Filter
BN3 — Red Filter
BN1 — RN2 — Red Filter
RN1 — Blue Filter
RN3 — Red Filter
B1 — Green Filter
B1 — B2 — Red Filter
B2 — Red Filter
B2 — Blue Filter

Posterization on Color Paper

63

The Sabattier effect

by Richard D. Zakia

A photograph having both positive and negative images, usually with a fine line separating shadow and highlight area. In color, the hues often are vivid and unnatural. The Sabattier Effect occurs when film or paper is reexposed to light during development.

A color print made from a KODAK VERICOLOR Print Film 4111 negative which had been reexposed to light during development.

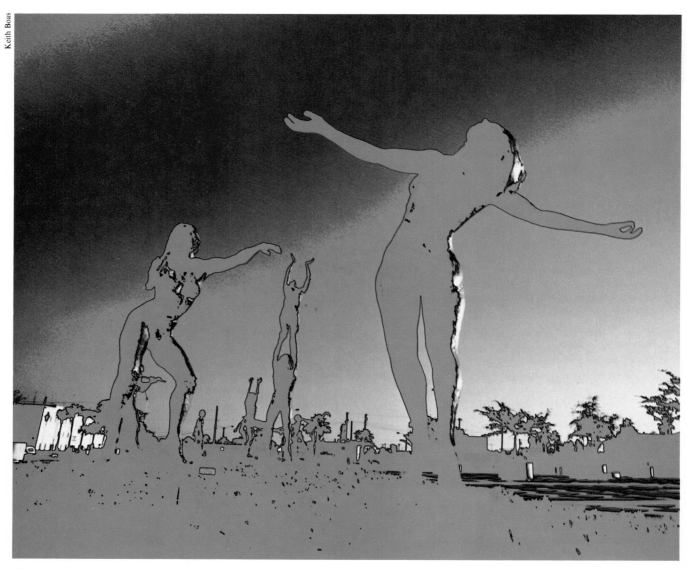

Keith Boas

Vive le Sabattier! It's a wonderful technique for adding fantasy and surrealism in the darkroom to your photographs. You don't need special equipment or photographic materials to achieve the Sabattier Effect. The technique simply involves fogging a sheet of normally exposed film or paper during development to produce a partial reversal of tones. The result is a creative image which is part negative and part positive. The reversal is most noticeable in the areas of the film or print that receive the least amount of first (normal) exposure.

While it's possible to produce the Sabattier Effect with black-and-white papers, highlight areas turn muddy gray as a consequence of the partial reversal. Selective bleaching with a solution of Farmer's Reducer (see page 28) can help restore some of the highlights but the print will still look somewhat muddy and flat. You can obtain better results with black-and-white papers by using nearly exhausted paper developer in which many prints already have been developed. Such a developer solution is partially oxidized and contains reaction by-products from previous development action.

With color papers, the highlights turn a color that is dependent upon the color of the illumination used for the reexposure stage.

Best results are achieved with high-contrast materials or by making a print from a negative to which you previously have given the Sabattier Effect. As a bonus, fine lines usually form between adjacent highlight and shadow areas during the partial reversal of tones. These lines serve to outline shapes, exaggerate their presence, and provide a new dimension to the photograph not available in any other way. Subjects which have strong shadow areas produce the most dramatic outlines.

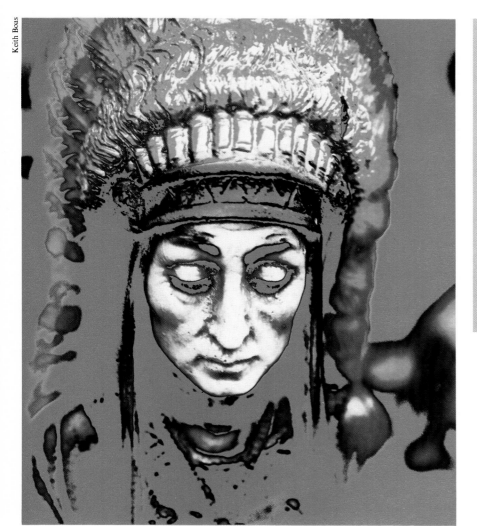

Keith Boas

TECHNIQUE

1. Give the film or paper a normal exposure.

2. Develop for about half the normal development time.

3. Reexpose the emulsion by fogging it with light for a brief time while it is in the developer. Be sure the developer solution is calm. Ripples on its surface can act as lenses, destroying the evenness of the reexposure.

4. Continue development for the last half of the normal time.

5. Rinse, fix, wash, and dry the film or paper normally.

Some experimentation may be required to get the desired results. The ratio of first-to-second exposures and first-to-second developing times are important variables. Decreasing the first developing time and increasing the second developing time while keeping the fogging reexposure constant usually increases the amount of tone reversal.

This image was derived from an original color slide as follows:

1. *The slide was enlarged onto a sheet of* VERICOLOR *Print Film.*

2. *Halfway through development, the* VERICOLOR *Film was reexposed 3 seconds under the enlarger, with slide removed.*

3. *The processed negative was printed onto* EKTAFLEX PCT *Negative Film with heavy cyan filtration (CC100C).*

BRIEF HISTORY

The Sabattier Effect was accidentally discovered around 1850 by French doctor and amateur photographer Armand Sabatier. (The original spelling of Sabatier was with one *t* but common usage is with two *t*'s.) While developing some wet collodian plates, he accidentally fogged them with light. Instead of discarding the plates, Sabatier took a chance and continued to develop them. After they were fixed, he noticed—much to his surprise—that the images were partially positive and partially negative.

In the 1920s, the same accidental discovery was made by the artist-photographer Man Ray. Ronald Penrose tells how Man Ray's assistant mistakenly switched on the light while a plate was being developed. "Examining the results of the accident, they discovered that the dark unexposed background in the negative had been exposed by the light which, at the same time, had been insufficient to affect the already exposed areas. A dark, narrow gulf remained between the differently exposed areas, giving the form in the areas originally exposed an outline so sensitive as to be the envy of any painter."* Man Ray became so skilled in producing the Sabattier Effect that he

Eastman Kodak Company

In the 1890's, solar energy was used at Kodak to make customers' black-and-white prints.

sometimes was accused of touching up his prints. Although he used the Sabattier Effect to maintain partial reversal and a dark line effect, he mistakenly referred to his prints, as solarized prints.†

To this day much of the popular literature does the same, although *pseudo*solarization is more appropriate.

You can now rediscover the exciting potential of the Sabattier Effect by intent and not by accident. Almost like magic, colors change, tones reverse, and dark lines appear in hundreds of different ways depending upon the conditions of exposure, de-

velopment, reexposure, and redevelopment.

*Penrose, Ronald Man Ray. Boston: New York Graphic Society, 1975, page 116

†One reasonable answer deals with the use of solar energy to expose photographic paper. In the early days of photography, it was necessary to contact-print negatives using direct sunlight to obtain sufficient exposure. If one took a break during exposure or simply forgot about the time, the prints might reverse, or *solarize*. Another reason for the popular use of the term may be that it is much easier to say you solarized a print than to say you gave it the Sabattier Effect.

THE SABATTIER EFFECT WITH BLACK-AND-WHITE NEGATIVES

Exposure Test

1. Contact print or enlarge a negative onto KODALITH Ortho Film 2556, Type 3. (The Sabattier Effect works best with a high-contrast image.) Bracket exposure times so you'll have a range of densities from which to choose an acceptable positive image. As a starting point, try exposure times in the 5 to 20-second range at *f*/8.

2. Develop the KODALITH Film in KODAK Developer D-19, undiluted, for 4 minutes, using occasional agitation.

Sabattier-Effect Sequence

1. Print the original negative onto another sheet of KODALITH Film using the best test exposure.

2. Develop the film emulsion up in D-19 Developer for 1 minute, using continuous agitation.

3. Stop agitating and let the developer settle for about 10 seconds. Do not remove the film.

4. Reexpose the film while it is in the developer for about 1 second with a 15-watt bulb at a distance of 3 feet (1 m).

5. Continue development for 3 minutes with *no agitation*.

6. Stop, fix, wash, and dry the film normally. You now have a positive image with partial reversal of tones.

7. Contact print the positive image onto KODAK Commercial Film to make a new negative (internegative).

8. Develop the film normally in D-19 Developer, undiluted, for 3 minutes with occasional agitation.

9. Stop, fix, wash, and dry the film normally. You now have a negative image with partial reversal.

10. Print this negative onto a normal grade paper.

Making the Test Print

Expose

Develop for 4 minutes with constant agitation.

Select the best exposure time.

Sabattier-Effect Sequence

First exposure

Set timer for 4 minutes.

First development—60 seconds with constant agitation

No agitation for 10 seconds

Fogging reexposure

Second development—no agitation

Stop when 4 minutes are completed.

STOP
FIX
WASH
DRY

Complete the remaining steps.

THE SABATTIER EFFECT WITH
KODALITH ORTHO FILM 2556, TYPE 3

Preparation

Use a KODAK 1A Safelight Filter (light red), or equivalent.

For best results, use KODAK Developer D-19, undiluted. KODALITH Developers are not recommended for this technique.

Alexander Syndikas

Straight print from the original negative

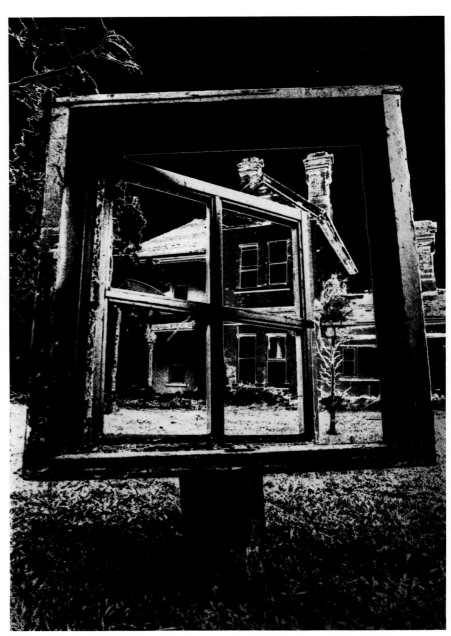

This print, showing the Sabattier Effect, is the result of several darkroom steps:

1. The original black-and-white negative was exposed onto KODALITH Film, which then was reexposed during development to produce partial reversal and a fairly contrasty line effect.

2. Next the resulting positive was contact-printed onto a sheet of KODAK Commercial Film to make a continuous-tone negative.

3. This new negative then was printed onto normal-grade paper to make the final print.

KODALITH Film produces dramatic results with the Sabattier Effect. By varying the reexposure time, you can make a high-contrast image that also includes gray tones in reexposed areas.

With high-contrast film, the Sabattier Effect outlines the image. To prevent streaks and produce vivid lines, don't agitate the film in the developer after reexposure.

From the original negative of a bus at night, a positive was made onto KODALITH Film, which then was given the Sabattier Effect. This print was made from that high-contrast positive.

69

Alexander Syndikas

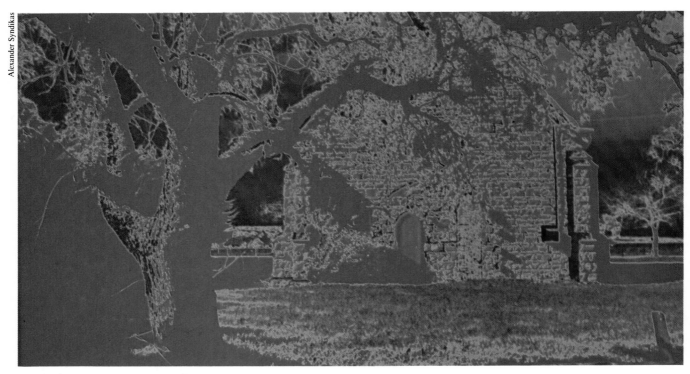

A straight print on EKTAFLEX PCT Reversal Materal from a VERICOLOR Print Film negative that had been briefly reexposed during development. Reexposure to produce the Sabattier Effect was made with a 15-watt bulb at 3 feet (1.9 m) for 5 seconds.

THE SABATTIER EFFECT WITH *KODAK VERICOLOR* PRINT FILM 4111

Exposure Test

1. Enlarge a color slide onto VERICOLOR Print Film, bracketing your exposure times at f/8. Try times of 8, 10, and 12 seconds for a 7x10-inch image. Use the filtration recommended in the instruction sheet which accompanies the film.

2. Process the print film in KODAK FLEXICOLOR chemicals, Process C-41, as recommended.

Sabattier-Effect Sequence

1. Enlarge the slide onto VERICOLOR Print Film using the best exposure determined above.

2. Develop for 1 1/2 minutes with continuous agitation.

3. Remove the partially developed print film from the developer and allow to drain for about 20 seconds.

4. Reexpose the film for 5 seconds with a 15-watt bulb at 3 feet (1 m). Or reexpose the film using your enlarger as the light source. Place the partially developed, wet film on a tray under the enlarger and expose it, with the slide removed from the enlarger, for a shorter exposure time than you gave it for the first exposure. Try about 3 seconds at f/8. You can use the same filtration as you did for the first exposure or vary it to shift the colors. (There is a reason for not exposing the film while it is in the developer as with the black-and-white technique. The C-41 Developer is not a clear solution and tends to act as a liquid filter.)

5. Return the film to the developer for 2 minutes with *no agitation*.

6. Remove the film and complete the processing as normally prescribed. You can turn the room lights on after the film has gone through the bleach.

7. If you want a final, paper print from this negative derivation, make a normal print from the processed VERICOLOR Film using KODAK EKTACOLOR Paper or KODAK EKTAFLEX PCT Negative Film and Paper.

Alexander Syndikas

A VERICOLOR Print Film negative showing the Sabattier Effect. First a color slide was enlarged onto the VERICOLOR Film. Then the film was reexposed during development to produce the partial reversal of the image.

A straight color print of the adjacent VERICOLOR Print Film negative

Richard Zakia

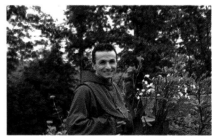

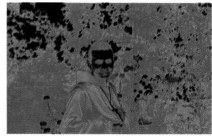

A straight print, made with EKTAFLEX PCT Negative Material, of the derivated color negative at right.

Top: *Original color slide*

Bottom: *VERICOLOR Film negative made from the slide and given the Sabattier Effect during development. Reexposure was by enlarger illumination.*

THE SABATTIER EFFECT
WITH *KODAK EKTAFLEX PCT* FILMS

For best results, start with a contrasty image. A color slide has much more contrast than a color negative. To increase the contrast further, print the slide onto EKTAFLEX PCT Negative Film. This will give a print with negative colors but will produce more contrast than if the slide were printed on EKTAFLEX PCT Reversal Film. Contrast is essential for the Sabattier Effect; representative color rendition is not a factor in the creative process. For starters, try the sequence described here.

The Technique with
KODAK EKTAFLEX PCT Negative Film

Enlarge a color slide onto EKTAFLEX PCT Negative Film. After the first exposure and lamination, give the film a second exposure (a brief flash) to light.

Key:

● Can be done under normal room lighting

● Do in complete darkness or under appropriate safelight conditions.

❶ First exposure: Try 25 seconds at f/5.6 with a filtration of 5 yellow and 10 magenta (5Y + 10M).

PCT FILM

❷ Slide the EKTAFLEX PCT Film into the Printmaker and soak it for 20 seconds.

KODAK EKTAFLEX PCT PRINTMAKER, MODEL 8

PCT PAPER (DARK SIDE UP)

PCT FILM

❸ Crank and laminate the film. First lamination: 7 minutes. The resulting print will appear as a negative image. Reds will be greenish, blues will appear yellow-orange, and whites will be black.

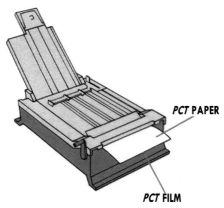

PCT PAPER

PCT FILM

❹ In the dark, peel the paper from the film.

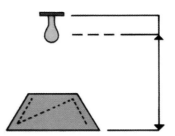

Reexpose the PCT Film to a 500-watt bulb for 1 second.

❺ Position a fresh sheet of PCT Paper on the Printmaker and return the film to the activator for a 5-second soak.

❻ Second lamination: 7 minutes. This print will exhibit tone reversal, and some line effects will appear. (If you want to try for a third print, go to step 7).

❼ Reexposure: Same as step 4

❽ Soak: Same as step 5

❾ Third lamination: 10 minutes. Print will appear as a pale pastel. The colors will be muted, and there will be severe loss of contrast.

Alexander Syndikas

Original color slide

**Lamination Time Variations Using
KODAK EKTAFLEX PCT Negative Film
and *EKTAFLEX PCT* Paper**

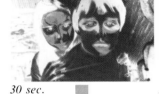 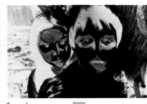 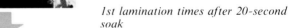

30 sec. l min. 6 min.

Reexposure

1st lamination: Produces a color-negative print. All prints received same exposure.

1st lamination times after 20-second soak

 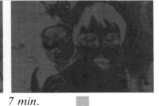

7 min. 7 min. 7 min.

2nd lamination: Prints reverse in tone and color. Some line effect is produced.

2nd lamination times after 5-second resoak

Reexposure

 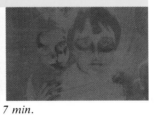

7 min. 7 min. 7 min.

3rd lamination: Prints become a dull, greenish pastel. The line effect is lost with extended lamination time.

3rd lamination times after 5-second resoak

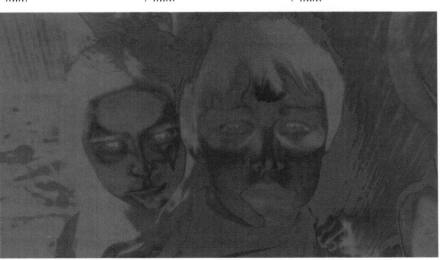

*Using the above lamination test as a guide, the final print, **left,** was made as follows: **1.** Using a fresh sheet of PCT Negative Film and the same original exposure, the negative was soaked for 20 seconds and laminated for 6 minutes. **2.** The negative then was exposed to a 500-watt bulb for 1 second. **3.** Next it was resoaked for 5 seconds and laminated to a new sheet of PCT Paper for 5 minutes. Note how the lamination time of the second laminate produced subtle color shifts.*

73

Adding texture

by David Engdahl

You can add a texture look when making prints from black-and-white negatives, color negatives and color slides. You apply the texture pattern by exposure through a mask called a texture screen. The screen may be as small as the negative or as large as—or even larger than—the photographic paper being used.

This pointillistic painting effect was achieved by making three filtered exposures on a single sheet of EKTAFLEX PCT Reversal Material through a grain texture screen. The original was a color slide. The technique of tricolor printing with a texture screen is explained on page 78.

Keith Boas

Some pictures look rather plain in their original state. To upgrade their appearance, you can add an overall pattern or textured semblance during printing. The way you do it and the pattern you choose can turn an ordinary-looking picture into an expressive and attractive photograph.

You can purchase ready-made texture screens or make them yourself. Homemade screens can be photographic images of various textures, such as brick, sand, or carpet weaving, or they can be made of translucent materials that have texture—including netting, a window screen, or a stocking.

COMMERCIALLY AVAILABLE TEXTURE SCREENS

Commercial (ready-made) texture screens come in two types: (1) small screens which are laid over the negative and printed with it, and (2) large screens which are printed in contact with the paper on the enlarger easel.

Small screens give good results and are much less expensive than the large, commercially prepared screens. Small screens also are easy to keep in complete contact with the negative by using a glass negative carrier in the enlarger. You simply place the emulsion of the texture screen against the emulsion of your negative in the carrier, and print them as one negative. By sandwiching a small texture screen with your negative in the negative carrier, you increase the size of the texture pattern as you increase the size of the projected image. This may or may not be advantageous to you, depending upon the intended use and viewing distance of your final enlargements. Unless you have an extremely fine texture pattern, the resulting texture could look quite coarse, especially in large blowups.

Large screens, because they are placed in contact with the printing paper, always yield the same sized pattern, regardless of picture magnification. The textured image also appears somewhat sharper and has more contrast—features that make large screens more popular among serious darkroom workers.

Photo-specialty dealers often carry ready-made texture screens in several sizes. Look at the screen, a picture of it, or an example of the effect it produces to decide whether the pattern is suitable for your needs. For example, you might prefer for printing certain portrait negatives a tapestry or canvas texture screen. It looks like a canvas surface and, if used carefully with a portrait negative, can give a rich, artist-painted appearance.

*A texture screen can add a new dimension to your prints. At the **top** is the straight, untextured print. The print at the **bottom** was made with a homemade, canvas texture screen placed in contact with the paper.*

A color print made with a commercially prepared etch texture screen placed directly on the paper during the total exposure time. The original was a color negative.

MAKING A LARGE PHOTOGRAPHIC TEXTURE SCREEN

Try various types of cloth. First hold the fabric to a bright light to see if it is fairly translucent and has an interesting visual pattern in its weave. You also might try samples of plastic sheets, available at art and building-supply stores. Some have very interesting texture patterns.

MATERIALS

A fabric or other translucent material with texture

KODALITH Ortho Film—the 8x10-inch or 11x14-inch size

KODALITH Developer

A piece of heavy plate glass

PROCEDURE

1. If you are using a piece of cloth, make sure that it is smooth. If necessary, iron it flat.

2. In your darkroom, adjust the enlarger so that the illuminated area is about 11x14 inches or a little larger. If you intend to make 8x10-inch prints, your texture screen should be at least this size.

3. Mark the area of illumination on the baseboard of the enlarger with masking tape so that you can positively locate the area when the enlarger lamp is off.

4. Equip your safelight with a KODAK 1A Safelight Filter (light red).

5. Set the enlarger lens at $f/8$. With the enlarger lamp off, place a strip of KODALITH Film, emulsion (light side) up, on the baseboard between the tape marks. Spread the textured material on top of the film. Hold it in contact with the film by covering it with a piece of plate glass.

6. Make a series of test exposures across the face of the film. Try exposures of 1, 2, 4, 8, 16 and 32 seconds.

7. Process the film normally in KODALITH Developer. After a brief wash, view the wet test film on an illuminator. Choose the exposure that gives you the most detail. If one step is too dark and the next is too light, use an exposure time between the two for your next step.

Sam Campanaro

8. Expose a fresh sheet of film through the textured material at the time judged to be best.

9. Process and dry. Call this finished film a *negative* texture screen. In most cases, you'll want to use this texture screen when printing your negatives. However, some positive texture screens produce a more interesting result. Whether to use a negative or positive screen depends upon the texture being used and the effect you prefer.

10. To make a positive screen, make a contact print of the finished negative screen onto another strip of KODALITH Film. Make a series of test exposures around the time used for the negative screen. Process and judge for fineness of detail. Select the test exposure producing a positive that's neither too dark nor too light.

11. Make a full-size positive screen from the negative screen using the best exposure.

This color print was made with a large texture screen placed in contact with the paper during exposure. The screen itself was a KODALITH Negative that had been contact printed with a piece of linen fabric.

COMMON MATERIALS AS TEXTURE SCREENS

Window screen

Linen

Nylon stocking. (Stretch the material and fasten it to a frame larger than the print you are making.)

Burlap

Textured glass

Netting

Any translucent material with a grained appearance

USING LARGE PHOTOGRAPHIC TEXTURE SCREENS

From this point on, you'll want to experiment to find out how much texture you like in a print.

1. Make a good print from a negative you think would be improved by the addition of texture.

2. Place an unexposed piece of photographic paper in your easel. Place a negative texture screen in contact with the emulsion of the paper and make a series of exposures. Try your original exposure plus increases of 5, 10, and 20%. Process and judge the print. Pick the area that suits you best in density. Make a full-size print with this new exposure.

3. If the screen appearance is too prominent, make another print, keeping the screen in the illumination path for only part of the exposure time. Let's say that your exposure time was 10 seconds. Place the screen over a new sheet of paper and make an exposure for 5 seconds. Carefully remove the screen—don't disturb the paper—and expose the paper for another 5 seconds.

4. A variation (below) is to make an exposure through the texture screen without the negative in the enlarger. Select an exposure that's just enough to produce a visible image. Make a second exposure through the negative without the texture screen.

*The textured print at the **bottom** was created in two exposures: 1. A brief exposure through the texture screen with no negative in the enlarger. 2. A normal exposure through the negative but without using the texture screen.*

Keith Boas

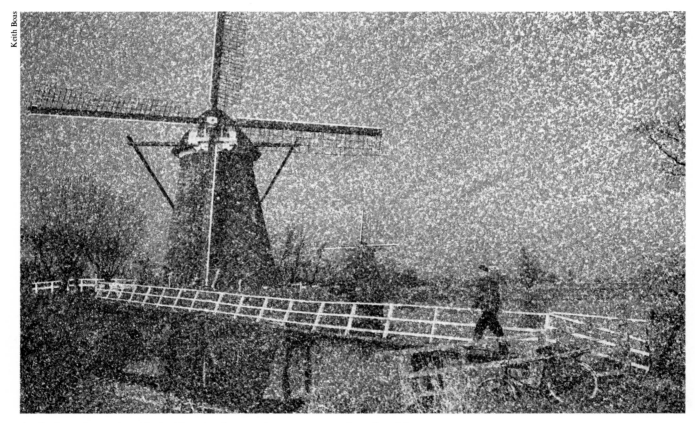

Keith Boas

A tricolor print made with the filters and approximate exposure times listed in the table. Between exposures, the grain texture screen was staggered to create dabs of color.

TRICOLOR PRINTING

Tricolor printing refers to making separate red, green and blue exposures instead of a single exposure with your normal CC filter pack only.

By slightly moving the screen between each exposure, you create a dabs-of-color effect similar to the pointillism technique of Impressionistic painters.

In addition to the deeply saturated filters, use the filter pack in your enlarger that normally would produce an acceptable single exposure print.

1. In the dark, place a texture screen in contact with the emulsion side of a sheet of EKTAFLEX PCT Negative Film or color paper.

2. Make a red-light exposure through a No. 25 gelatin filter.

3. Move the screen slightly and make the green-light exposure through a No. 99 gelatin filter.

4. Move the screen slightly again and make the blue-light exposure through a No. 47B gelatin filter.

5. Process in the normal manner.

Try different screen patterns and pattern sizes for the effect you desire. To achieve a desirable color balance, you may have to adjust your individual red, green and blue exposure times. You can use the exposure suggestions in the table as a guide for getting you started.

You also can use a texture screen over the color-printing material during a single exposure with your normal filter pack. The resulting pattern would be similar to the effect on a black-and-white print.

Tri-Color Exposures on
KODAK EKTAFLEX PCT Negative Film

Filter	Exposure time— 7.5X at $f/8$*
No. 25 red	10 seconds
No. 47B blue	40 seconds
No. 99 green	50 seconds

*For making an 8x10-inch print from a 35 mm color negative

TEXTURING YOUR NEGATIVES

You can build into your negatives a permanent texture screen via reticulation. The condition is produced by a combination of chemical treatment and temperature shock to your film. However, the reticulation pattern is impossible to be removed later. For this reason, you may prefer to make copy negatives for the reticulation step as described on the next page. Or you can make a reticulation-pattern texture screen.

Laura Bethel

An 8x10-inch, black-and-white print made from a reticulated PLUS-X Pan Film negative. To reticulate the negative, the photographer followed the procedure below except for the optional step 4, which was skipped.

Reticulation

The following technique produces a reticulation pattern on black-and-white film during its initial development. Since this effect is somewhat unpredictable and nonreversible, you may not want to use the technique on a roll of film having original images. However, if you have a favorite picture that you want to reticulate, first make a good print and then copy it with KODAK PLUS-X Pan Film. After you have exposed the film process it as follows:

In total darkness:

1. Using KODAK Developer D-76 diluted 1:1 with water, develop the film normally according to the manufacturer's instructions.

2. Rinse the film in an acetic acid stop bath for 1 minute at a temperature

of 140 to 150°F (60 to 66°C).

3. Immerse the film in a cold water bath — below 40°F (4°C) — for 1 minute.

4. **This step is optional. It emphasizes the reticulation pattern of the emulsion but does not otherwise change it.**
 Immerse the film in hot water— 180 to 190°F (82 to 88°C) — for 1 minute. Then quickly immerse it into another cold water bath—below 40°F (4°C).

5. Fix the film normally, at normal room temperature, with a fixer that contains a hardener such as KODAK Rapid Fixer.

6. Wash the film in running water for 20 to 30 minutes.

7. Do *not* use KODAK PHOTO-FLO Solution or any other wetting agent. Dry the film quickly using a portable hair dryer, directing the warm air across the surface of the film.

SIMULATING RETICULATION WITH A TEXTURE SCREEN

If you don't want to reticulate original or copy negatives as described, you can make a texture screen with a reticulated pattern. Give an overall fog, or flash, exposure to a fresh sheet of lith film. In the dark, briefly fog a sheet of KODALITH Film to white light; then process and dry it as above to create a reticulation pattern. You can use this negative, now a texture screen, to produce a texture when printing any of your existing black-and-white negatives, color negatives, or color slides.

Printing with paper negatives

by Keith Boas

A paper negative is an image which has been recorded on photographic paper and is used as the negative to make the final print. Prints made from paper negatives usually display some paper texture and lack extremely fine detail. The effect produced can have a look similar to that of a charcoal drawing or an antique photograph. By changing the grade of paper used, you can also create a high contrast, posterlike appearance.

Paper negative made from a 35 mm color slide. While this chapter concentrates on ways to make paper negatives as intermediate steps to positive prints, the paper negative itself often can be an artistic, final image.

Laura Bethel

CONTRAST CONTROL

The paper-negative technique offers you considerable potential for local control. You can manipulate contrast and density quite easily through your choices of paper grade and exposure. In addition, retouching lets you emphasize highlights and subdue distracting elements.

Chances are, that you want the shadow and highlight details of the final paper-negative print to match closely those of a carefully made normal enlargement from the same camera negative. However, this is not a simple task to achieve since contrast increases each time an intermediate step is introduced in photographic reproduction. To offset visually this inevitable buildup of contrast, make your intermediate paper positive (diapositive) and paper negative low in contrast by using a No. 1 grade paper or a No. 1 filter with a variable contrast paper.

Since these intermediates actually are used as transparencies, judge their density by transmitted light, not by reflected light as you would an ordinary print. Make your intermediates considerably darker from what you normally would consider acceptable print density. Viewed by reflected light, each intermediate should seem far too dark—to the extent that normally white areas appear light gray. But when you hold each dark diapositive or negative to a bright illuminator to judge exposure by transmitted light, even the darkest shadow areas should display full detail. Your aim should be intermediates that, when viewed by transmitted light, appear normal in density, but have easily discernible detail in both highlights and shadows, and are very low in contrast. The lower the contrast, particularly in the diapositive intermediate, the easier it is to retain detail at both ends of the tonal scale in the final print. Because the process has a tendency to gain contrast when going from step to step, the final print will be so contrasty that it probably will be unsatisfactory unless you intentionally keep the contrast of the intermediate low. If for some reason you want higher contrast in the final print, it's a simple matter to choose the appropriate grade of printing paper at that point. If you are working with variable contrast paper, simply select a higher numbered filter to cover your enlarger light source.

Straight print from the original negative

Final print made from a paper negative. Considerable retouching on the intermediate positive and negative removed the pile of concrete blocks from the foreground plus two cars parked down the road. "Clouds" were added with a pencil at the paper-negative stage.

THE PAPER-NEGATIVE PROCESS

Fix, wash, and dry prints after each step before proceeding to the next step.

1. Starting with a normal negative, make an enlargement, cropped and dodged as you want the final print to be.

2. Use a soft pencil on the back (base) surface of the processed print to darken any area that needs to be subdued. (See page 83.)

3. Contact-print the enlargement onto another sheet of photographic paper to make a paper negative. For maximum sharpness, place the paper surfaces emulsion to emulsion.

4. Apply pencil retouching on the processed paper negative to intensify the highlights in the final print.

5. Make the final print by contact-printing the retouched paper negative with another sheet of photographic paper.

Keith Boas

Final print made from the retouched paper negative. The contact print was made using a print frame and enlarger illumination. Selective-contrast paper with a No. 3 filter.

This diapositive print was made dark and low in contrast (flat) deliberately with a No. 1 filter on a selective-contrast paper.

Low-contrast paper negative made from the diapositive at left. The exposure was made with a No. 1 filter.

The base side of the paper negative was retouched with a pencil to accentuate some of the highlights in the scene.

PAPER FOR PAPER NEGATIVES

Most sensitized photographic papers will work for the paper negative technique, although some types have advantages over others. Single-weight papers are generally preferred because they contain less paper fiber to diffuse the image. Fiber also can produce a slightly textured appearance in the final print, with heavier weight papers producing the effect more noticeably. However, this trait might not be of concern to you, as many prefer the paper negative technique because of the textured appearance possible.

Aside from your choice of paper thickness, you can also control the texture and detail shown in the final print by the way you expose it. For maximum detail, expose the print normally with the emulsion side toward the light source (emulsion-to-emulsion). For minimum texture, flash the paper through the base with the light of your enlarger; then turn it over and expose it, emulsion side up, to the paper negative (emulsion-to-emulsion). To soften detail, expose the paper through the base (base-to-emulsion) with no separate flash. This procedure also emphasizes texture.

Texture and appearance of the final print also can be controlled by the surface of the paper you select for the first step. For very little texture, select paper with a smooth—A, E, F, J, or N—surface. For a heavily textured effect, use an R, Y, or X surface.

Many resin-coated papers are watermarked on the base with the identification of the manufacturer. The contrast buildup from step to step usually will prevent this identification from transferring visually to the final print but to be completely safe, you can scatter those faint watermark images into oblivion simply by using a diffused light source such as room illumination for exposing the paper in the intermediate, contact-printing steps.

RETOUCHING

A distinct advantage to working with paper negatives is that they can be retouched easily. By using a soft pencil on the base of the paper diapositive, you can tone down areas that distract from the center of interest. Applying pencil marks selectively to the base of the paper negative can emphasize highlights in the final print. For viewing ease and accuracy when retouching, place the paper on a bright illuminator.

Most fiber-base papers have good "tooth" on their base sides that will take any soft pencil easily. One paper in this category that often is used for the paper-negative technique is KODBROMIDE Paper. When retouching on resin-coated papers, use a soft pencil designed for glass, plastic, metal and paper—such as the All-Stabilo #8008 Marker, available through art-supply stores.

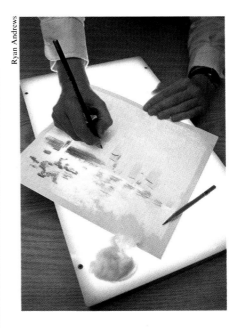

For viewing ease when retouching a paper negative, place the paper— emulsion down—on a bright illuminator. Reduce the chance of unwanted smudges by working from the center outward.

STARTING WITH A NEGATIVE

1. Choose a negative having a subject that relies more on broad effects rather than fine detail.

2. Enlarge the negative onto a soft-grade photographic paper. Process and dry the paper. You now have a positive print (paper diapositive). If your original is a color negative, use a panchromatic paper for better tone reproduction of the colors. KODAK PANALURE or RESISTO Rapid Pan Paper has good characteristics for this use.

3. Retouch the diapositive, if necessary, with a soft pencil on the paper base to subdue distracting areas.

4. Contact-print the paper diapositive onto another sheet of the same, low-contrast paper to make a paper negative.

5. Retouch where needed to brighten the highlights in the final print. Use a soft pencil on the paper base as you did in step 3.

6. Contact-print the paper negative onto another sheet of paper for the final, positive print.

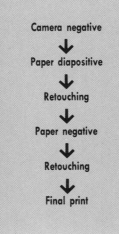

Camera negative
↓
Paper diapositive
↓
Retouching
↓
Paper negative
↓
Retouching
↓
Final print

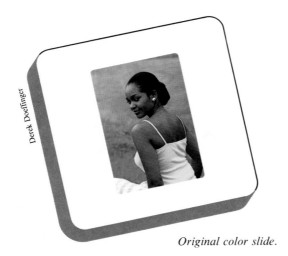

Derek Doeffinger

Original color slide.

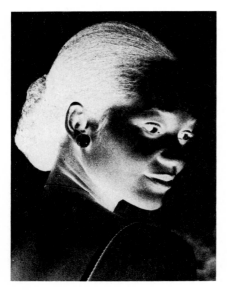

8x10-inch paper negative made directly from the slide by projecting it onto a No. 1 grade enlarging paper

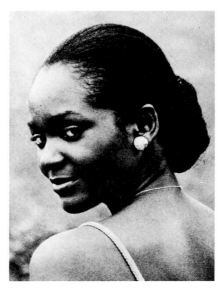

The final print on No. 1 grade paper made from the paper negative. Contact printing was done by the wet print technique described in the text.

FLATTENING THE PAPER

To produce a sharp image at each stage of the paper negative process, your intermediate diapositive or paper negative must be in uniform contact with the unexposed paper during exposure. The weight of a heavy piece of glass or the pressure of a printing frame while contact printing may not be enough to completely flatten a badly warped intermediate print. Rewet the back of the print, put it between blotters, and press it until it's dry under something smooth and heavy, or between two pieces of 3/4-inch (19 mm) plywood or chipboard, tightly clamped together.

For an alternate method of flattening prints and allowing for uniform contact of the two sheets of paper, first soak the diapositive print in water for about two minutes. Then, under appropriate safelight conditions, place a fresh sheet of unexposed paper on a clean, flat surface with the wet print on top of it, emulsion to emulsion. Carefully squeegee the two sheets together and make the exposure. A 75-watt bulb about 4 feet (1.2 m) above the paper will require an exposure of approximately two seconds, depending on the sensitivity of your paper. Bracket your exposures first using a test strip to determine best exposure for your situation. After processing and retouching (if necessary) the resulting paper negative, perform the same procedure for making your final print.

STARTING WITH A SLIDE

1. Choose a slide having a flat lighted, low-contrast subject.

2. Enlarge the slide onto photographic paper. To keep the contrast as low as possible in the resulting paper negative, you'll probably have to dodge the highlight areas and give additional exposure to the shadows. If your slide has substantial areas of dominant color, use a panchromatic paper, such as PANALURE Paper, for better tone reproduction.

3. Retouch highlight areas, if necessary, for cleaner whites in the final print.

4. Contact-print the paper negative onto another sheet of paper for the final, positive print.

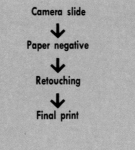

Camera slide
↓
Paper negative
↓
Retouching
↓
Final print

Keith Boas

Straight print on medium contrast KODABROME II RC Paper

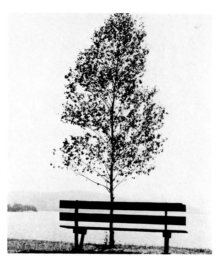

The same negative, printed on No. 5 grade paper to make a contrasty diapositive

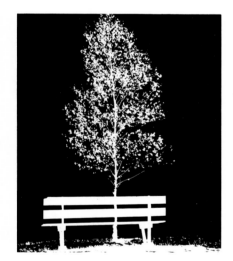

Paper negative made from diapositive using another sheet of No. 5 paper. After the paper negative was washed and dried, it was retouched with a permanent-ink felt marker to opaque unwanted elements.

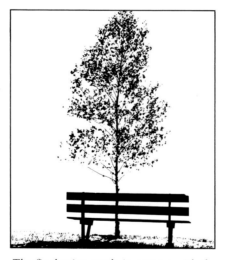

The final print, made in contact with the paper negative on No. 5 grade paper

MAKING HIGH-CONTRAST PAPER-NEGATIVE PRINTS

If you want to make a high-contrast derivation from a normal negative but have no KODALITH Film available, simply use the paper negative technique with a contrasty grade of paper. You'll achieve dramatic, two-tone posterizations that will have nearly the detail possible with the traditional litho film method described on pages 48 and 49.

1. Choose a black-and-white negative with broad areas in its subject matter.

2. Enlarge the negative onto grade 4 or 5 paper or selective-contrast paper with a No. 4 filter. Process normally in paper developer and dry the print.

3. Where preferred, retouch out distracting elements in shadow areas by using an opaque material such as a permanent-ink felt marker. Retouch on either the emulsion or base side while the print is placed on an illuminator.

4. Contact-print the paper diapositive with another sheet of contrasty paper. Process normally and dry the print.

5. Using an opaque material again, retouch the paper negative as required to delete unwanted areas in the highlights.

6. Contact-print the paper negative with another sheet of grade 4 or 5 paper for your final, high-contrast print.

Camera negative
↓
Contrasty paper diapositive
↓
Retouching
↓
Contrasty paper negative
↓
Retouching
↓
High-contrast final print

Printing without negatives

by Keith Boas

A photogram is a shadowlike picture made in the darkroom by placing an object between the light source and film or photographic paper. The object (subject) can be resting on or suspended above the photographic material, or inserted into the negative carrier of your enlarger. Subjects can be opaque or translucent—extremely flat or three-dimensional.

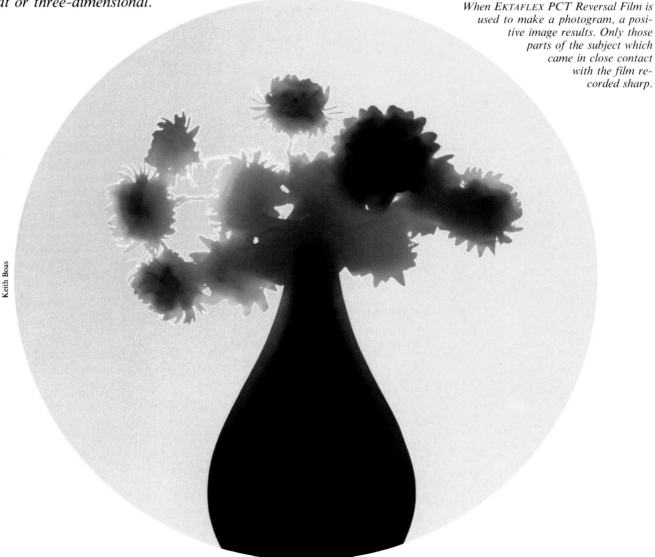

When EKTAFLEX PCT Reversal Film is used to make a photogram, a positive image results. Only those parts of the subject which came in close contact with the film recorded sharp.

Keith Boas

MAKING PHOTOGRAMS

You can make a photogram (a picture created without a camera) by placing objects between the light beam of your enlarger and a sheet of light-sensitive film or paper. Following the exposure step, you process the sensitized material in the normal way. With traditional negative-producing films and papers, the resulting picture has a dark background and white or near-white silhouettes of the objects. With color reversal materials, you get a positive image.

For flexibility in composing the image, use 8x10-inch paper or film. Select props that are in scale with this size format. Then in the dark or under appropriate safelight illumination, put your paper or film emulsion up into the enlarging easel, directly under the enlarger head. Lay your props either directly onto the easel or onto a sheet of glass suspended above the easel. The latter arrangement produces softened or blurred edges. You can elevate the glass by resting it on blocks of wood placed on opposite sides of the easel. By placing objects both on and above the easel, you can create sharp and blurred images simultaneously.

Another technique for making a photogram involves placing a *flat* object in your enlarger's glass negative carrier, then projecting it in focus as you would do with a traditional negative. For this procedure, you must have a glass carrier to hold the object in a flat plane. For some good subject ideas, consider natural objects, such as leaves, feathers, insect wings, or blades of grass. Flat subjects placed in the negative carrier give you the flexibility to crop and change the size of the image while maintaining excellent sharpness.

Color Photograms with
KODAK EKTAFLEX PCT Materials

KODAK EKTAFLEX PCT Negative and Reversal Films both are easy to use for the photogram technique. As final results can be seen in less than 10 minutes after exposure, you can judge exposure, color balance, and composition quickly and accurately. The negative film will produce a dark background and a silhouette of opaque subjects in white. By adjusting exposure and filtration, you can make the background go any color hue and intensity. With EKTAFLEX PCT Reversal Film, you'll achieve a white background and dark silhouette—a positive-image photogram. By using translucent objects, such as vegetation or certain fabrics, you can reproduce close approximations of their actual colors.

With either material, adjust the enlarger head about 3 feet (0.9 m) above the easel. To determine the best photogram exposure with your equipment, make a series of exposures on a single sheet of film in the 5 to 30-second range at $f/11$.

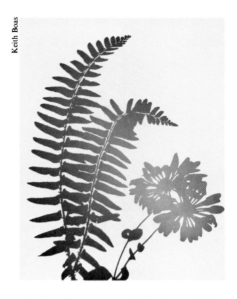

Keith Boas

A color photogram made by laying fresh flowers over an 8x10-inch sheet of KODAK EKTAFLEX PCT Reversal Film and exposing the film to white (unfiltered) light from an enlarger

The setup for the above photogram. Props were placed on a sheet of glass resting on the easel so that the film could be slipped in and out (in the dark) without distrubing the composition.

Photograms with Instant Color Film

Positive Images. Normally, KODAK or KODAMATIC™ Instant Color Films produce a positive image. For example, where white light strikes the film, a white image will appear after development of the picture unit. Objects placed onto a sheet of unexposed film will reproduce as black shapes (no exposure) when the film is exposed and developed. A 7 1/2-watt lightbulb placed about 4 feet (1.2 m) from the film works well as a light source. Try an exposure of 1 second. If the image appears too light for your tastes, place the light source farther away or shorten the exposure time. If the picture is too dark, you need to give the film a little more exposure in the next try. Move the lightbulb closer or lengthen the exposure time.

1. With all lights off in the darkroom, place an instant film cartridge containing at least one unexposed picture unit onto the floor or table directly under the light source. Use a 7 1/2-watt bulb at a distance of 4 feet (1.2 m). The film (picture unit) side of the cartridge must face up with the black cover sheet removed.

2. Arrange your object or objects to be recorded directly on the film surface.

3. Make the exposure by turning on the light for 1 second. (For critical timing, plug the light fixture into an electric darkroom timer of the type normally used with enlargers.)

4. Remove the object from the film surface and insert the cartridge into an instant camera. You can turn on the room lights now.

5. Eject the picture unit from the camera by tripping the shutter, covering the lens while you do it to avoid the chance of further exposure to the film. If you have a manual-eject camera, you also will

have to turn the hand crank. Processing begins automatically as the picture unit passes through the camera rollers and is ejected from the camera.

As KODAK Instant Color Films are color-balanced for daylight, you might want to place a No. 80A gelatin filter in front of the light source for some color correction. For convenience in attaching the filter to the light source and also for eliminating stray illumination, put the bulb into a gooseneck desk-lamp having a small reflector. Tape the filter to the front of the reflector with masking tape. But be careful of heat buildup, which could damage the filter. Leave the light on for only a few seconds.

Negative images. If you greatly overexpose the film with an intense blast of light when making a photogram, an image reversal (positive-to-negative) phenomenon occurs. (The reversal, being a product of extreme overexposure, is called solarization, which is described on page 66.) Instead of an overexposed, positive image appearing on the developed picture unit, the opposite happens. The unusual reversing action causes a negative image to appear upon development. You might have seen this effect in a picture of a sunset taken on instant film where the extremely bright sun reproduced as a small, *black* circle in the sky. Strong specular highlights on chrome, glass, or water surfaces will also record as tiny, black images if their brilliance is extreme.

Keith Boas

A positive-image photogram of a padlock on KODAK Instant Color Film. Exposure was 1 second with a 7 1/2-watt bulb at 4 feet (1.2 m) above the film.

A negative-image photogram on KODAK Instant Color Film. A No. 25 red gelatin filter, taped in front of the flash, produced tones of cyan (the complementary color to red) in areas receiving heavy overexposure. Areas receiving little exposure did not reverse and so reproduced in varying tones of red.

To make this unique, re-reversal effect work in your favor, use a portable electronic flash unit as your light source. In a room that is completely dark, place a cartridge containing instant film onto the floor, film side up with the object to be recorded lying on the film. Stand near the cartridge and hold your flash unit at arm's length above your head. Fire a flash directly down at the film. Next remove the object from the film, pick up the cartridge, load it into an instant camera, and eject the picture unit in the normal manner.

If you use colored light to produce the strong overexposure, its complementary color will appear. For example, extensive overexposure to green light results in a magenta image. (See the table on page 42.)

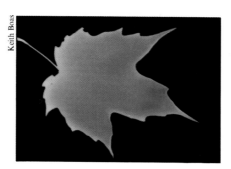

A green translucent object, such as this leaf, produces a magenta image when the instant film is greatly overexposed by flash. An unfiltered electronic flash unit was aimed at the leaf, which had been placed on the film cartridge. Flash-to-film distance was 7 feet (1.8 m). You can vary density in the image somewhat by changing the distance. The closer the flash, the darker the resulting image. Autumn leaves don't work well as the colors are usually poorly saturated.

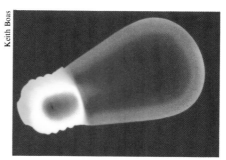

For this photogram, a frosted light bulb was placed onto the unexposed surface of the instant film. Electronic-flash exposure through a No. 38A deep-cyan filter produced varying degrees of color reversal.

CONTACT-PRINTING WITH A BLAST OF LIGHT
The images here extend instant-print solarization one step further, combining the reverse-image photogram technique with a normal or high-contrast negative as subject matter.

A print made from the original 4x5-inch black-and-white negative. The subject is peeling paint in an automobile junkyard.

Here exposure was made by electronic flash covered with a No. 25 red filter.

Again, electronic flash was used to produce the reversal image. A No. 38A deep-cyan filter covered the flash.

Switching processes

by Larry Sribnick

*This section deals with making high quality black-and-white
enlargements or instant color prints from color slides. It also
shows you how to create eye-catching derivations by breaking the
rules—printing negatives and slides onto materials not usually
associated with one another.*

*Tracks in snow take on the appearance
of an abstract pattern when reproduced
as a negative image. Color slide printed
onto EKTAFLEX PCT Negative Film*

Keith Boas

Michael Donovan

Original color slide

Print made from straight copy negative

Print made from copy negative that had been exposed through a No. 25 filter

MAKING BLACK-AND-WHITE INTERNEGATIVES FROM COLOR SLIDES

One easy way to get a black-and-white print from a color slide is to have a color internegative made, and make a print from the negative onto KODAK PANALURE Paper as described in the KODAK Workshop Series book *Black-and-White Darkroom Techniques* (KW-15).

Another way is to make your own black-and-white negatives from slides by copying the slides using black-and-white negative film and a single-lens reflex (SLR) camera. SLR cameras let you make excellent quality black-and-white internegatives easily. Modern, through-the-lens metering practically has eliminated the need for exposure calculations.

Basically, the idea is to take a photograph of the original color slide as if you were taking a photograph of the original scene. However, this time you're going to load the camera with a black-and-white, fine-grain, panchromatic film—such as KODAK PLUS-X Pan Film— instead of color film. And instead of focusing on a subject several feet away, you focus on a subject that's only a few inches from the camera.

Equipment

To copy the slides, you'll need some equipment for close-up photography. You can use extension tubes, a bellows, or macrolens with a diffusion screen, or a conventional slide copier unit. In making your copy negative, try for as close to a 1:1 size ratio as possible for a big image on the negative so that you can make enlargements of any size later with relative ease.

By using black-and-white panchromatic film, you can make your copy negatives with almost any light source. If you're using flash with an automatic camera, check to see whether your camera metering system will read flash as well as continuous illumination, and set your lens accordingly. Or, use a predetermined aperture and a manual setting.

Exposure and Development

Unless you want to correct the density (exposure) of a slide that is either too light or too dark, copy the slide just as it appears. This can be a problem if the slide is deliberately dark, such as in a night scene. The metering system will "see" it as underexposed and try to correct it by overexposing the internegative. Use the under- or overexposure biasing controls of your camera or set the exposure manually to control the situation.

Another way to determine the correct exposure is by taking a meter reading from a 0.80 (16% transmission) neutral density filter instead of the individual slides. (Set the exposure manually or use the camera auto-exposure lock.) In this way, different brightness values will reproduce correctly, with dark slides copied as dark subjects and light slides as light ones.

A third alternative for determining exposure is to read the white ground glass of your slide copier with no slide in place. Then manually open the lens by 2 2/3 stops, and copy your slides at that setting.

You can modify the exposure and development of PLUS-X Pan Film to make your internegatives easier to print. Slight overexposure and under-development will reduce the contrast and allow for more shadow detail. Instead of setting your camera meter at the recommended speed of ISO (ASA) 125 (normal for PLUS-X Pan Film), use a speed of 64. To compensate for this 1-stop overexposure, shorten the development time slightly. For example, if you use KODAK Developer D-76 diluted 1:1 with water at 68°F (20°C), cut the time from 7 to 6 minutes. Later, you can fine-tune the contrast of the prints to your liking with the appropriate paper grade or variable-contrast filter.

Filtration

Most of the filters that are used for black-and-white photography can also be used with this copying technique. Darkening a blue sky is simply a matter of slipping a No. 15 yellow or No. 25 red filter between the light source and the slide when you copy it. To heighten the resulting monochrome tones of green foliage in a slide, copy it through a No. 58 or 61 deep green filter.

MAKING INSTANT COLOR PRINTS FROM SLIDES

You don't need an elaborate dark-room to make color prints from your slides—just a room that can be made dark, a color enlarger, and either KODAK or KODAMATIC Instant Color Film plus an instant camera to process the film.

The idea is simple. Instead of exposing the film inside the camera, you expose it—with the lights off—by projecting the image of your slide onto the surface of the film using an enlarger. You then process the film by inserting it into an instant camera and tripping the shutter to eject the film. As the film ejects, it passes through the camera rollers which spread processing chemicals across the image area. Be sure to cover the lens while tripping the shutter to avoid additional exposure. Also, keep track of the number of film units you expose, as the film counter on the camera will reset to "0" each time you open the film compartment door.

If you have a KODAK Instant Film Back, designed for use on traditional view cameras, it's even simpler. All you do is press a button and the back will process the film for you by ejecting it through its rollers.

Although a normal, 50 mm enlarging lens will work fine, it's easier to use an 80 mm lens, as it will require a higher enlarger head position for the desired image size. This extra distance will give you a little more working room under the enlarger. An 80 mm lens also will make it easier to project a small image if your enlarger has a short bellows.

Don't use any safelights once you have removed the cover from the film pack as instant color film must be handled in total darkness.

Use either a standard enlarging lamp or a tungsten-halogen light source. The table below lists some suggested starting-filter packs.

| Lamp Type | Filter Pack | |
	EKTACHROME Slides (E-6)	KODACHROME Slides
No. 212	30C + 20M	40C + 45M
No. 302 or Tungsten-Halogen	20C + 20M	20C + 35M

This color print was made by enlarging the accompanying slide onto KODAK Instant Color Film. No chemicals or plumbing were required—only a color enlarger and darkroom plus a KODAK Instant Camera for processing the picture unit.

Test print with exposures, from left to right, of 1, 3 and 9 seconds

EXPOSURE AND DEVELOPMENT

To start, make an exposure test at 1, 3, and 9 seconds at $f/22$. If you still have too much light, try a 0.30 neutral-density filter, which transmits only half the light, or add gelatin filters CC30C + CC30M + CC30Y to the existing filter pack to achieve the same amount of neutral density. For each CC30 you add to all three colors, you reduce the exposure by the equivalent of 1 stop.

After ejecting the film unit, you can judge exposure in about 3 minutes. But you should wait at least 15 minutes before you evaluate the image for proper color.

If you are using an instant camera to process the picture, you will need an empty film pack to focus and compose the image. Slip a piece of heavy white paper into the pack so that you can see the image being projected. A second empty pack will be useful to properly align the film packs with the enlarger because the packs are tapered. By placing the film packs back to back so that the stripes match, the taper is, in effect, eliminated—making the surface of the film parallel to the baseboard.

With KODAK Instant Color Films, exposure actually is made through the back side of the film. This means that when you insert your original color slide into the enlarger carrier, you must position it emulsion up, the opposite of what you would do when printing pictures conventionally. This backward positioning will yield an instant copyprint having correct left-to-right image orientation.

Kodak instant film packs are tapered. By using an empty pack as a spacer, the surface of the film (picture unit) in the fresh pack will be parallel to the baseboard of the enlarger. Be sure to place the packs back to back with the colored stripes matching one another. Tape the empty back to the baseboard to keep it from slipping out of alignment with the enlarger beam.

Insert the color slide emulsion side up into the enlarger's carrier. This position will provide correct left-to-right orientation in the resulting instant print.

INTERCHANGING *KODAK EKTAFLEX PCT* MATERIALS

You can create some eye-catching photo derivations by printing negatives or slides onto photographic materials not usually associated with one another. Black-and-white negatives and color slides can be printed onto paper or film intended for color negatives while color negatives can be printed onto materials intended for color slides. (See **PRINTING BLACK-AND-WHITE NEGATIVES IN COLOR,** on page 42.) Each combination is capable of producing images that are real show stoppers. KODAK EKTAFLEX PCT Color Printmaking Products for printing both color negatives and slides, make the exploring of these color-printing avenues easy and enjoyable.

Because prints made using these products are abstract, the composition, color and contrast of the scene are given new, dramatic importance. Negatives and slides chosen should have simple, bold compositional elements. Easily recognizable tones, such as flesh tones, might not work very well but a more abstract sunset or snow scene often will work just fine.

Printing Color Slides

You can print color slides on EKTAFLEX PCT Negative Film for a bold, dramatic effect. The resulting prints will be the opposite of the original slide in both color and density. Light areas in the slide will be dark in the print. Blue sky will be yellow or orange depending on the filter pack used. Use a piece of unexposed, processed color-negative film in the negative carrier above or below the slide just as when printing black-and-white negatives onto EKTAFLEX Negative Film.

Robert Johnston

Because of the abstract nature of this technique, simple, bold images work best. Here a color slide was printed onto EKTAFLEX PCT Negative Film, which then was processed and laminated normally to EKTAFLEX PCT Paper. Exposure was 11 seconds at f/16 with a 20M + 20C filter pack.

Tape a strip of unexposed, processed color-negative film to the top side of the negative carrier. EKTAFLEX PCT Negative Film is designed to work with color negatives which have this built-in mask. The mask in this case will make it easier to control the color of the final print.

Ryan Andrews

Printing Color Negatives

Printing color negatives onto EKTAFLEX PCT Reversal Film will give you a very different kind of print. Color negatives and EKTAFLEX Reversal Film are both low-contrast materials. The prints made using this combination tend to be softer and subtler in tone. Because the film is a reversal material, light areas of the negative will be light in the print and red areas of the negative will be red in the print, too.

It isn't necessary to add a piece of unexposed, processed color-negative film above the negative carrier for this technique. In fact, the results will be better if the mask is, in effect, neutralized. To do this, use a filter pack of CC65C + CC05M as a starting point. If you want to modify the color of the resulting print, simply change this starting filter pack.

The point to remember when using any of these techniques is that there is no such thing as a bad print. Prints may be different from one another but none of them is wrong. Feel free to experiment, and don't be afraid to say to yourself, "What would happen if I . . ."

Keith Boas

Printing a color slide onto EKTAFLEX PCT Negative Film will give you strong, contrasty colors that are the opposite of the colors in the original slide. An earlier exposure test indicated that additional exposure was necessary to increase color saturation and add detail to the shadows. Exposure for this print: 17 seconds at f/8

*Printing color negatives onto EKTAFLEX PCT Reversal Film will give you subtle colors in the resulting transfer print. You have a choice as to whether or not you want the overall mask of the color negative to show in the print, **top.** If you don't, try a starting filter pack of 5M + 65C to diminish the effect of the mask, as was done when making the **bottom** print. Exposures for these two prints were: **Top**—40 seconds at f/8 (no filtration); **Bottom**—22 seconds at f/3.5 (5M + 65C filtration)*

Index